GOODBYE,
OLD MAN

GOODBYE, OLD MAN

OLD MAN

MATANIA'S VISION OF THE FIRST WORLD WAR

LUCINDA GOSLING
IN ASSOCIATION WITH MARY EVANS PICTURE LIBRARY

The
History
Press

IMAGE CREDITS

All images in this book are taken from *The Illustrated London News* archive, housed and managed at Mary Evans Picture Library, except for the following:

David Cohen Fine Art/Mary Evans Picture Library: pp. 7, 29, 34, 42, 59 (bottom), 79, 86, 89, 92, 103, 108; The Estate of Fortunino Matania/Mary Evans Picture Library: pp. 8, 30, 31, 36, 65, 66, 67, 68, 73, 77; Mary Evans Picture Library: pp. 71, 72, 74; The Mercian Regiment Museum (Worcestershire): p. 80; Robert Hunt Library/Mary Evans Picture Library: p. 82.

First published 2014

The History Press
The Mill, Brimscombe Port
Stroud, Gloucestershire, GL5 2QG
www.thehistorypress.co.uk

British Library Cataloguing in Publication Data.
A catalogue record for this book is available from the British Library.

ISBN 978 0 7509 5597 3

Typesetting and origination by The History Press
Printed in Great Britain

INTRODUCTION

In 1937, Fortunino Matania, the famous Italian artist, appeared at Marylebone Police Court. He was charged with having in his possession at 104 Priory Road, Golders Green, a machine gun, four rifles and a quantity of ammunition, all held without a firearms licence. Signor Matania's cache was not in any way intended for violent or murderous acts but was in fact a small part of a vast collection of props amassed over his career. The defendant pleaded guilty but explained the weapons had been used in his studio for painting pictures of the First World War, and the ammunition had come in boxes sent to him by the War Office while working as an official war artist. Dismissing the summons on payment of £5 5s costs, the judge ordered for the weapons and ammunitions in question to be handed back to the War Office.

Many artists through history have gone to great lengths to achieve their masterpiece, whether it is Michelangelo spending years up a scaffold to decorate the Sistine Chapel or Banksy leaving a building-sized artwork under the nose of surveillance cameras in London. For Fortunino Matania, his work was built upon two watchwords: accuracy and authenticity. A studio full of historical costumes, artefacts and, for two decades at least, army-issue ammo, went some way to achieving this aim, but this artist's most effective weapon was not one he kept stored in his studio. Matania possessed a prodigious, natural artistic ability, an enquiring mind and a lifelong love of history. In addition, he had a commodious photographic memory, enabling him to conjure up scenes and events with awe-inspiring speed and precision,

using just a few quick-fire sketches as reference. Accuracy, speed and realism were all qualities that were to make him a virtuoso artist-reporter, highly sought after by the illustrated papers of the early twentieth century. During the First World War, it was to be *The Sphere* magazine that could boast Matania as their leading 'special artist' and he produced hundreds of highly accomplished illustrations for the publication during this period, leaving a legacy of imagery unsurpassed by any other artist or, arguably, photographer of the time.

Matania's career as a commercial artist seems almost to have been pre-destined. He was born in Naples in 1881, and his father Eduardo and cousin Ugo were both well-respected artists who made illustrations for a number of high-grade Italian publications including the leading weekly magazine, *L'illustrazione Italiana*. Matania, showing an early aptitude for drawing, joined the family firm and trained in his father's studio where he was taught artistic disciplines other than drawing and painting, including sculpture and wood carving. This holistic approach trained the young artist to appreciate form, shape and perspective – the figures populating his pictures would always exhibit a solid, sculptural quality reminiscent of Classical statues and particularly the Victorian neo-Classicist painter, Lawrence Alma-Tadema.

Fortunino showed a remarkably precocious talent. A sketch of a goat, made when he was 3 years old, shows an astonishing ability. At the age of 9, he produced his first commercial illustration – designing a soap advertisement – and then, aged 11, painted a picture that was hung in the Academy of Naples. By 1895, aged just 14, he was working in his father's studio, churning out illustrations of such prodigious quality Eduardo deemed them good enough to be reproduced in the respected illustrated paper, *L'Illustrazione Italiana*. It was only when Mantania visited the paper's office with his father to demonstrate his talent that the editor overcame his disbelief that a child could produce such sophisticated work. He was employed, aged 15, by the paper as a 'special artist', where the only obstacle he encountered was occasionally being refused admission to the state functions and ceremonials he had been asked to cover. On presenting his press card, most officials declined to admit someone of such youthful appearance, assuming he had stolen his

father's pass. A sketch, done on the spot to prove his abilities, was often the only way he could be allowed to complete his mission. He travelled to Paris in 1901, where he briefly worked for *L'Illustrazione* before his soaring career trajectory took him to London, the birthplace of the illustrated weekly and where, in 1902, at the age of 21, he began to contribute illustrations to another prestigious publication, *The Graphic*. The forthcoming Coronation of King Edward VII required an artist of uncommon ability and Matania was considered the man for the job.

Photographers were not to be present at the sacred ceremony but nor were sketchbooks or notepads; Matania was able to employ his unique skill and drew almost every scene from memory. The results established his reputation as the pre-eminent magazine artist of the day. Around this time, Matania returned to Italy to complete his National Service, though he continued to fulfil commissions for magazines in Britain and worked for

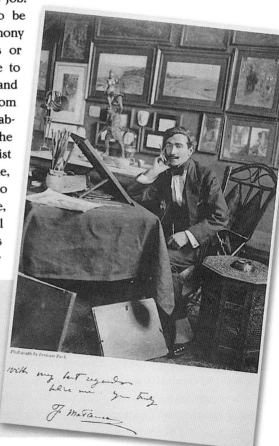

Fortunino Matania (1881–1963) pictured in his studio around the time of the First World War. Always dapper, Matania had an ingrained Italian sense of style and was rarely pictured without a bow tie, spats and immaculately groomed moustache.

The Illustrated London News (*ILN*) for a spell. He served in the 8th Regiment of the Neapolitan Bersaglieri and left the barracks of Pizzofalcone at Santa Lucia in the Bay of Naples with a lasting memento of his time spent there. Inside, he painted six panels showing the art of combat through the ages, demonstrating two of his favourite artistic genres – war and history.

In 1904, after a period where he had taken on freelance commissions including coverage of the Russo-Japanese War for *L'Illustrazione*, he formed a more permanent relationship with a comparatively new magazine. *The Sphere* had been founded in 1900 by Clement Shorter, a former editor of the *ILN* and *The Sketch*. It aimed to rival both the *ILN* and *The Graphic* with the quality and quantity of its illustrators and in 1904 it signed a contract securing the services of Matania as a 'special' artist for the foreseeable future, a partnership that was to be long and fruitful.

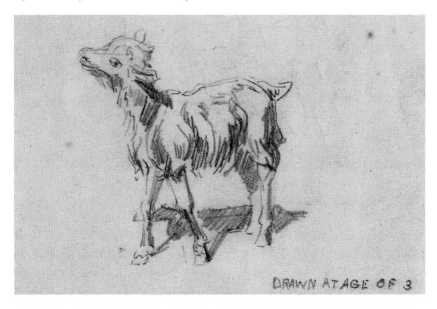

A kid goat, drawn by Matania at the tender age of 3, demonstrating his remarkable precocity.

Front cover of *The Sphere*, 20 May 1911, by Matania, featuring King George V and his cousin, the German Emperor Wilhelm II, at the unveiling of the Queen Victoria Memorial in London.

The subjects Matania painted for *The Sphere* were spectacularly diverse, though it was unusual for him to produce a picture without people in it. In fact, the more people the better often seemed his mantra – his pre-war images teem with life, chronicling society at work and at play. There are scenes of London at the height of the season – audiences at the opera, debutantes presented at court or dinner dances at smart hotels. He revelled in depicting any event that featured costumes or fancy dress, such as balls at the Albert Hall, pageants and, particularly, royal ceremonials. In 1911, he was invited by King George V and Queen Mary to travel with them to capture the magnificence of the Delhi Durbar, where he had the benefit of a prime position at the foot of the dais. In order to blend in, Matania obligingly donned a military dress uniform in the sweltering temperatures, all the while absorbing the spectacle of 'oriental luxury' and committing it to memory. His record of the occasion, numbering several pictures, was published in Britain just two weeks later – an extraordinary feat – and he was presented with the Coronation Medal for his efforts. The speed with which he was able to work – and produce pictures ahead of his

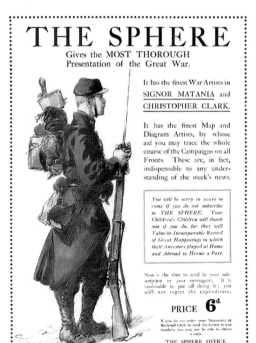

THE SPHERE

Gives the MOST THOROUGH Presentation of the Great War.

It has the finest War Artists in SIGNOR MATANIA and CHRISTOPHER CLARK.

It has the finest Map and Diagram Artists, by whose aid you may trace the whole course of the Campaigns on all Fronts. These are, in fact, indispensable to any understanding of the week's news.

You will be sorry in years to come if you do not subscribe to THE SPHERE. Your Children's Children will thank you if you do, for they will Value its Incomparable Record of Great Happenings in which their Ancestors played at Home and Abroad so Heroic a Part.

Now is the time to send in your subscription to your newsagent. It is inadvisable to put off doing it; you will not regret the expenditure.

PRICE **6**ᵈ

If you do not order your Newsagent or Bookstall Clerk to send the *Sphere* to you regularly you may not be able to obtain a copy.

THE SPHERE OFFICE, Great New Street, London.

Advertisement for *The Sphere* from December 1916 boasting it had the finest artists in 'Signor Matania' and Christopher Clark. The magazines goes on to warn wavering subscribers: 'You will be sorry in years to come if you do not subscribe to *The Sphere*. Your children's children will thank you if you do, for they will value its incomparable record of great happenings in which their ancestors played at home and abroad so heroic a part.'

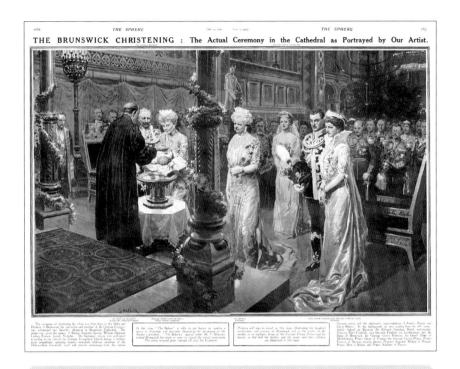

THE BRUNSWICK CHRISTENING : The Actual Ceremony in the Cathedral as Portrayed by Our Artist.

Matania travelled to the German Duchy of Brunswick in May 1914 to record the christening of the baby son of the kaiser's daughter, the former Princess Viktoria Luise of Prussia. Painted from life, Matania was at the very heart of German royal events just a few weeks before the war's outbreak.

rivals – was demonstrated in 1922 at the wedding of Princess Mary (King George V's daughter) to Viscount Lascelles. Before the ceremony, the Dean of Westminster allowed Matania, along with other magazine artists, access to Westminster Abbey to allow them to draw and prepare backgrounds in advance. They would then have two hours after the wedding to fill in any other details seen on the day. When the artists took their places at the abbey they saw, to their distress, that everything had been changed, making their

drawings up to that point completely inaccurate. Matania was not one to be beaten by such a hiccup and described his reaction to this muddle:

> I left the church just before the wedding ended and got jammed in the crowd. The police made frantic efforts to get me through by lifting me up and passing me over the heads of the people. My tall hat was squashed, but I got a taxi to the office and did a whole new drawing.

His pictures were the only ones published to be fully accurate. In the same year, Shorter, keen to pull off a coup over one of the biggest stories of the day, persuaded Matania to have ready in advance a picture of the opening of Tutankhamen's tomb by Howard Carter, insisting that Matania would be able to produce a faithful impression of whatever lay within the tomb. The artist visited the British Museum, studied books and Egyptology and read the reports from Egypt, producing a picture that was published the moment the news was announced. It turned out to be nearly identical to what had been discovered. No record exists as to what Matania was paid to be *The Sphere*'s special artist but whatever it was, he was worth it.

Whenever Matania was unable to draw from personal observation, he combined eyewitness accounts, maps, diagrams and his own imagination to logically build up a faithful representation of events. When the ill-fated White Star Liner *Titanic* sank down into the icy waters of the North Atlantic on the night of 15 April 1912, there could be no better artist to recreate the panicked last moments on board the ship than Matania. Reliant on the reports of those who had been there, photographs of the artist interviewing a survivor from the disaster were published in *The Sphere*. Always dapper, with his smart overcoat and spats, Matania's expression and body language convey concern and empathy, but also an alert determination to wheedle the exact details

Opposite: A wounded Belgian soldier, recovering in the VAD hospital at Hayle Place, Maidstone, demonstrates battle positions for two nurses with the aid of matchsticks. Matania would frequently visit wounded men in hospital and ask them to re-enact battles using toy soldiers.

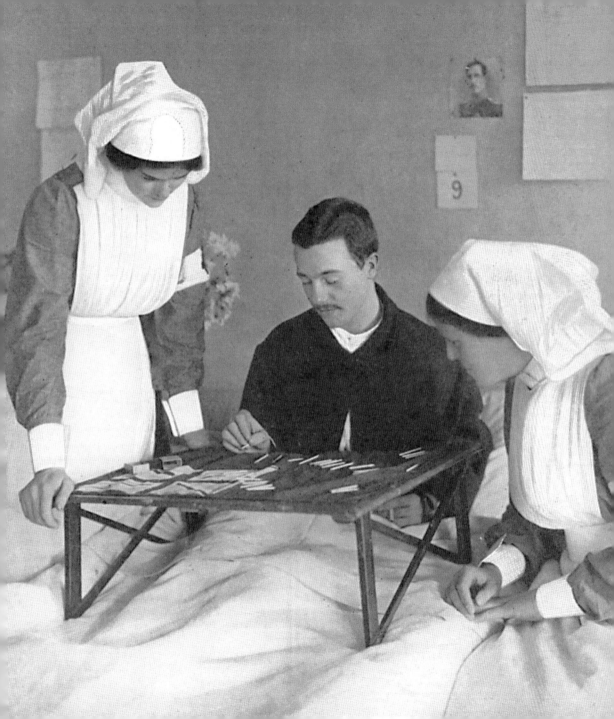

out of his interviewee in order to form the most faithful representation of a terrible tragedy.

A few months before the outbreak of the First World War, Matania was in the German duchy of Brunswick for the christening of the baby son of Princess Viktoria Luise, Duchess of Brunswick, only daughter of the Kaiser. That such an occasion should demand the attendance of *The Sphere*'s star artist, less than three months before Britain would be at war with Germany, indicates to some extent how unexpected subsequent events were. But the pre-war *Sphere*, as with many magazines, took a regular interest in Germany and particularly in its royal family, which was inextricably connected through a web of marriages to the British royal family. The kaiser, after all, was King George V's cousin. Matania painted them together in 1911, when the German emperor visited London for the unveiling of the Queen Victoria memorial, and several of Matania's paintings hung in the kaiser's palace.

In August 1914, Matania, aged 33, should have headed back to his native Italy to re-join the army, but the British government negotiated the retention of his services; as a national of an Allied nation he was employed as an official war artist, with the majority of his work published in *The Sphere*. The next four years were to mark the apogee of Matania's output, as well as call on all of the artist's reserves of ingenuity and resourcefulness. For the first few months, as the German army marched through Belgium and the British Expeditionary Force fought desperately to stem their advance, Matania remained in London; all his pictures are based on eyewitness accounts. One of his first of the war, depicting a scene between Le Cateau and Landrecies, shows an assortment of wounded British soldiers struggling out of the rubble of a bombarded church in which they had been resting in search of a more sheltered spot. Matania composed the scene after spending many hours among the wounded at the London Hospital, a dispensation given by Captain Fenwick of the Royal Army Medical Corps. *The Sphere*'s caption, in a thinly veiled comment on the German barbarism frequently referred to in the British press, noted that the church had the Red Cross flag flying over it.

Two weeks later, a depiction of a charge by French light cavalry was drawn according to material supplied by Harold Ashton, the *Daily News*

correspondent in France who had just returned from the front. Another, appearing in October 1914, depicting the British forces in the famous Grand Place at Bruges was drawn from a sketch by American sculptor Jo Davidson. George Horace Davis, a fellow *Sphere* artist (who would himself have a long career with the *ILN* as a diagrammatic artist), was in Hartlepool when the town was bombarded by German warships in December 1914; Matania worked up a complete picture from Davis's sketch. And a picture of the Royal Army Medical Corps at work in the trenches published in *The Sphere* on 6 March 1915 was the culmination of a description given by Sir Frederick Treves, chairman of the British Red Cross.

Matania's high standing and influence may have allowed him to call in favours from some of the war's most notable journalists and personalities, but wounded men (Belgian and French, as well as British) continued to be his most regular source of information. Using their vivid accounts, given from hospital beds, Matania was able to conjure up a succession of dramatic and realistic compositions. On these frequent visits, Matania would often arrive equipped with maps and a box of toy soldiers in order to re-enact the exact positions of men and weapons during a particular battle or event. Sometimes these collaborations were family affairs. Matania's father Eduardo and his cousin Ugo were also regular contributors to *The Sphere*. The three artists' styles are remarkably and eerily similar, but sometimes Ugo would provide explanatory diagrams to his cousin's grandiose double-page spreads. A painting of the heroic stand of 'L' battery of the Royal Horse Artillery by Matania appeared in *The Sphere* on 14 November 1914 and was accompanied in the same issue by a highly detailed diagram drawn by Ugo from an aerial perspective, showing the exact positions of the numerous casualties (men and horses) in that terrible action. Both illustrations were derived from the account of one of the gunners who had been present and survived.

This intense commitment to recreating a faithful and true-to-life portrayal of events was to result in an artistic output throughout the war that not only rivalled photography, but often surpassed it. Photographic journalism still had its limitations and scenes of actual combat and offensives were rare, unable to capture the detail, dynamism and emotion so evident in Matania's work.

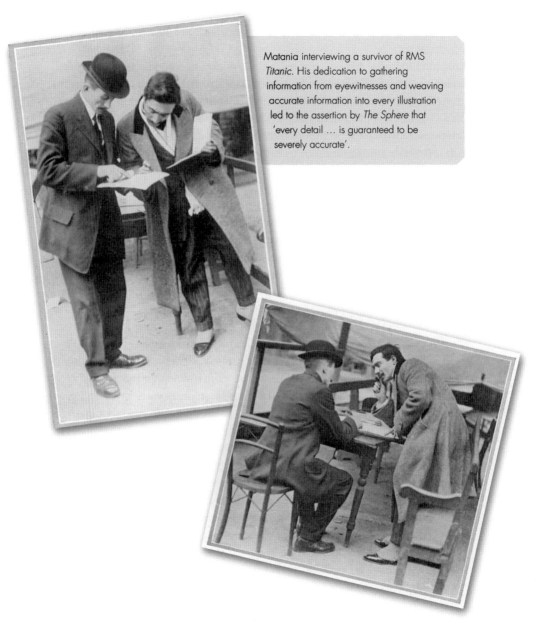

Matania interviewing a survivor of RMS *Titanic*. His dedication to gathering information from eyewitnesses and weaving accurate information into every illustration led to the assertion by *The Sphere* that 'every detail … is guaranteed to be severely accurate'.

He was not the only illustrator to use sketches, photographs and eyewitness accounts as references for paintings. His colleague at *The Sphere*, Christopher Clark, also produced pictures in this way, as did their French artist Paul Thiriat; it was a common method employed by most illustrated magazines. However, it was Matania's style and finesse that set him apart, making his work the gold standard for reportage illustration. His skilful handling of light and shade was usually created with gouache and watercolour paints in a palette of white and grey 'en grisaille', sometimes with evidence of pen and ink, pencil and crayon, depending on the finish of the image. Most illustrations were reproduced in magazines using the monochrome half-tone process and this technique was better suited to reproduction. The resulting pictures are almost photographic in their realism and, yet, he also had the artist's advantage of being able to move a figure here or there to achieve an altogether more satisfying composition. In this way, Matania can be said to bridge the gap between the two art forms. When *The Sphere* issued a portfolio set of twelve reproductions of Matania's pictures, the *Manchester Guardian* in a review commented how they were 'as much like a photograph as possible, but with more appearance of bustle and movement. Mr Matania's drawings are exceedingly clever examples of their class, livelier and more complete than most others, and showing great skill in suggestion of detail and in treatment of lighting.'

These details, over which Matania took such pains, were rendered with pinpoint accuracy and it is impossible not to be struck, when leafing through wartime copies of *The Sphere*, by the unexpected superiority of illustrations over photographs. That many were based on the first-hand accounts of serving soldiers and sailors, some of whom may have endured a particularly terrifying or painful experience, add an even deeper resonance to his work.

Around this time, Matania became the subject of one of a series of portfolios issued by artist, art teacher and publisher, Percy Vernon Bradshaw. The portfolio, which chose a rip-roaring illustration of a German Uhlan being repulsed at a Belgian barricade, revealed to the public for the first time Matania's singular method of working. The expectation is for an artist to sketch out his composition roughly, gradually building and embellishing across the entire picture until it reached completion. In a series of six

sequential pages, Matania's extraordinary technique showed him to work from the faintest of outlines but complete different parts of the picture to an almost finished standard until all the jigsaw pieces of finely detailed parts made a whole. It's likely that this opportunity to showcase his talent was relished by the Italian showman.

In the spring of 1915, Matania made the first of several trips to the front, visiting the area around Ypres and seeing the still-smouldering battlefield of Neuve Chapelle. In an interview in the *British Legion Journal* in 1933, he recalled how, unlike most soldiers who were brought to the front in gradual stages, he found travelling within twenty-four hours from 'civilian life and the peaceful atmosphere of the studio to the most infernal horror that history has ever recorded' something of a shock. There, sketching the debris left behind and noting the positions of the dead, many of whom still gripped weapons, he gathered material for a picture, 'Neuve Chapelle, 1915', which was exhibited at the Royal Academy in 1918. The mission was not without its dangers. Matania described the conditions he was working under in a narrative accompanying the picture in *The Sphere*. It gives us an awe-inspiring insight into the lengths he went to as a war artist:

> The din of the storm had died away, but the battlefield was still hot, smoky, and littered with relics of the fight. I went right across the open space, passing the first line of trenches, and stopped in the second line. The third line had also been wrested from the Germans, but it lay behind the village. It was not necessary for me to see further, for the ground round me would have provided me with material for a dozen pictures – if I had been able to make my sketches where I liked without fear of my labours being cut short by a bullet through the brain. I walked, or rather ran, for just under a mile, keeping as close to the ground as I could, and all the time I kept saying to myself, 'If I get out of this all right I'll do a picture which shall be as near the real thing as it can be'.

Interrupted by machine-gun fire, he ducked down in a trench but, keen to get a view of the village of Neuve Chapelle, bobbed his head up for a

split second to take in the scene. While sketching the nearby debris of the battlefield, including a kettle, an old bottle and a sardine can – all of which would end up in the completed painting – a shell burst just 5yd away, showering his sketchbook with grit and dirt, causing him to seek refuge in a nearby dug-out. Still not satisfied, he persuaded his guide to take him to an old observation post to get a better view. The experience affected him more than he imagined it might:

> When I got back to my comfortable billet behind the Lines, I could scarcely eat, and in my bedroom afterwards I suddenly burst into tears. What struck me so forcibly was the outward cheerfulness contrasting so grimly with conditions of the most dreadful horror.

He recalled once sitting chatting with some men near the front line and sitting on an upturned keg, only for his foot to shift and a human hand to be dislodged in the mud beneath. On another occasion he found a soldier lying on a stretcher with a bullet wound to his head, and was struck by the realisation that he had spoken jovially with the same soldier only a few days before.

Back in England at his country home near Potters Bar, Matania picked up his spade:

> Once at home I dug a trench in my garden, I made a dozen or so blue sandbags similar to a German one which I had brought back with me, and with the aid of a couple of hundred others, and of my sketches made on the spot, I did my best to construct a replica of the corner of the battlefield shown in my picture. When I had dressed my models in the original uniforms picked up on the field and placed them in the same position, I really had the impression of being there again. Except for the action of the figures, which had to follow information received on the spot, the picture is a faithful copy of this little corner of the battlefield of Neuve Chapelle, 1915.

Locals passing by would peer through the fence at the curious spectacle in the garden beyond and the recreation of the Western Front in miniature,

Portrait of Matania from *The Sphere*, 1 May 1915, at the time of his first visit to the front.

complete with British and German soldiers striking ferocious poses against each other one moment and then breaking out of character to joke good-naturedly with each other the next. In 1922, Matania offered this painting, of which he must have been particularly proud, to the Imperial War Museum. His offer was declined.

Articles by Matania, who was also a capable writer, described visits to the famous 'Plug Street' (Ploegsteert) Wood near Ypres (which he of course painted) and time spent with a British battery. At Plug Street, he saw trees riddled with bullets, the communication trenches famously named after London streets – among them Piccadilly and Regent Street – and met soldiers at rest in improvised club houses, napping, making tea, writing letters home or shaving in a mirror reduced somewhat by a German sniper's sharp shooting. In *The Sphere*'s 10 July issue, he described, too, the risky process of moving along a communication trench, where snipers were a constant danger. Above the sandbags he saw 'the horror of war in full display. I saw the body of a horse which was slowly decomposing and sinking into the earth, yet it could not be removed, because it was certain death for anyone to attempt to move it. An officer said to me, "If you are tired of life, try to reach it," and yet the body was only a few yards away.'

Following a period spent with an artillery battery, his description of the intricate network of transport and communication sections connecting

together to enable the guns to operate seemed almost to overwhelm even the self-assured Matania:

> Everything moves like clockwork in these varied realms of activity, whose sole object is to serve the guns. But the steel monster remains hidden away under a frail roof of boughs or straw or even a few rags, with its threatening muzzle thrust into the air like some determined tyrant serviced by a legion of workers, so numerous they pass out of sight over the horizon far away into the homeland. If I could only include all this in a single picture – but it is beyond my powers! I find it difficult even to bring this mental picture together in words.

At one point during his observations of the artillery, a gun emplacement was directly hit by a shell, causing it to run backwards right over Matania's right foot. However, as it simply pressed his foot further into the soft mud, he escaped uninjured. (Ironically, Matania would later be involved in a traffic accident in London in which a lorry ran over the same foot. This time it was amputated; Matania carved an artificial foot for himself, having been dissatisfied with anything else on offer.)

Further on in this article is a pertinent comment. It was published in June 1915, just after the so-called 'Shell Scandal' in which General Sir John French was interviewed by *The Times* and blamed the disappointing progress on the Western Front on the army's lack of sufficient armaments. Matania witnessed for himself a gun team avoiding what seemed like an obvious target – an observation post used by the Germans. Though his questions about this were evaded by those accompanying him, it was clear the decision was dictated by a shortage of shells. He did not hold back on letting his own views be known:

> I began to realise why it was that the bronze mouths hungered so for their daily food. If I had to leave my studio, paint brushes and palette, I would not direct my steps to a recruiting office, but I would go straight to where the lathe hums and quivers, and I would do my best to produce shells and

more shells, being convinced that by so doing I was giving the most useful possible service to the nation at the present time.

This bleak state of affairs was rectified a short time after when Lloyd George was created Minister of Munitions and set about creating dedicated government ordnance factories, many of them employing women as workers affectionately known as 'munitionettes'. Naturally, a munitions factory formed the subject of another of Matania's pictures, published in *The Sphere* on 24 June 1916, in which he conveys the grand scale of shell production within a staggeringly cavernous factory. Matania loved to paint women and this picture is notable for featuring as a model, in its centre, his secretary Ellen Jane Goldsack, usually known as 'Goldie'. Goldie would eventually become his second wife, in 1960, when Matania was the ripe old age of 79. (Matania had married his first wife, Elvira Di Genarro, in 1905 and the couple had one son and one daughter together; their daughter Clelia Matania had a successful career as an actress.)

Matania continued to produce scenes of action and everyday life on the Western Front, but he also painted numerous pictures of the war at sea. His paintings of the sinking of the *Lusitania* in May 1915 (again from an eyewitness account) were particularly affecting, and his portrait of John 'Jack' Travers Cornwell, VC, the boy who had remained at his post on HMS *Chester* during the Battle of Jutland despite being mortally wounded, was reproduced subsequently in a number of children's books such as Charles E. Pearce's *Stirring Deeds in the Great War* and G.A. Leask's *Golden Deeds of Heroism*, though later interpretations would be sanitised for the schoolboy market.

Throughout the war, Matania combined his superlative artistry with a nose for a good story. More often than not, he would have to seek these out. But in 1916, he was lucky enough for one of the biggest news stories to land almost on his doorstep. At the time, Matania was living in Potters Bar, in Hertfordshire, and on the night of 2–3 September he was able to witness the destruction of the L-21 German airship, Schütte-Lanz SL11 (often referred to as a Zeppelin), over Cuffley. The airship was famously brought down by

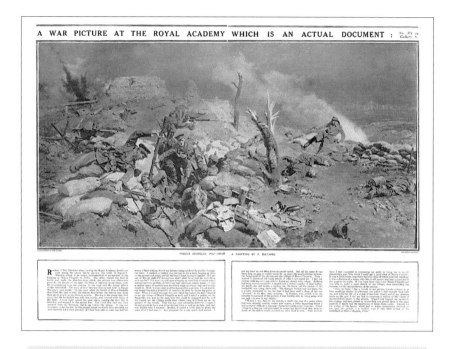

'Neuve Chapelle, 1915' by Matania. This painting was exhibited at the Royal Academy in 1918 and *The Sphere* published a black and white reproduction on 15 June, along with a narrative by Matania describing the lengths he went to in creating the picture. The original oil, reproduced on p. 80, is now in the possession of the Royal Worcestershire Regiment Museum.

Lieutenant William Leefe Robinson (who earned the Victoria Cross for his actions) and Matania was able to see the glowing conflagration from his house. He was first alerted to the airship by the distressed kicking of his pony on the door of its stable and, going outside, saw 'a thing like a silver fish gleaming in the immensity of the darkness. Along came the Zepp surrounded by a continuous glitter of tiny sparks, each one leaving a tiny puff of smoke.' As shell splinters began to fall through the sky, Matania put on his steel helmet and lay on the grass looking up at the sky through binoculars:

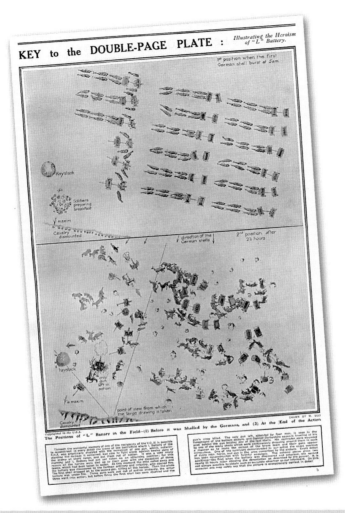

An aerial diagram by Matania's cousin Ugo showing the position of the ill-fated but heroic stand by L Battery of the Royal Horse Artillery at Néry. Fortunino produced two aspects of the VC-winning action and Ugo's drawing not only gives a further perspective; it also shows that, as a family, they would often collaborate on projects.

Suddenly, just as if they had turned on an electric light inside her, the Zepp lit up like a giant lantern. Flames burst out from the centre. My heart stopped beating. In an instant the flames spread all over her, and the monster broke in two. For miles around the country was illuminated as if by daylight. Her heaviest part fell first, and I saw the twisting of her intricate structure as she slowly began to come down. Then through an inferno of fiery sparks she plunged into some trees not far from where I lay with an awful crash of crumpling metal.

Matania dashed back to his darkened studio, grabbed an overcoat and ran out. He claimed, in his interview with the *British Legion Journal*, that he was first on the scene, which was by now a huge bonfire. It was just as well he was alone, as at that moment he realised he was wearing a German military overcoat and hastily slipped it off, bundled it up and hid it behind a tree lest anyone should imagine he were a miraculous survivor of the crash. He drew the wreckage the following morning, describing it as a 'mass of grey wire in inextricable entanglement ... all that was left of the flaming titan of a few hours before'. Again, Ugo provided additional illustrations, showing the six stages of the airship's demise.

As much as Matania was an expert at observing real-life events, he could also imbue his pictures with humour or pathos when called for, and it is notable that two of his most famous pictures are not of set-piece battles or heroic charges, but instead depict simple and very identifiable human interactions. In May 1915, he exhibited a watercolour entitled 'The Strongest' at the Royal Academy. Its subject, a defiant little boy sticking his tongue out at a burly German officer, was well received by the art critic of *The Times*, who wrote:

Mr Fortunino Matania gives us merely an illustration, but a vivid and amusing one: a Belgian or French boy putting out his tongue at a German soldier as his mother leads him by with averted face. It is effective because not exaggerated. The German is not violently brutal. He looks at the boy rather stupidly, as if uncertain whether to take any notice of him or not.

In 1916, Matania was commissioned to paint what would become his best-known work. 'Goodbye, Old Man', subtitled 'An incident on the road to the battery position in Southern Flanders', shows the heart-breaking farewell between a gunner and his wounded horse, as in the background, amid shell explosions, his comrades urge him to hurry and join them. It was originally painted for the Blue Cross Fund to raise money to relieve the suffering of war horses in Europe and was subsequently issued by *The Sphere* in several variations. It was apparently the model for the 58th Division memorial at Chipilly, created by the French sculptor Henri Désiré Gauquié, which was also a figure of an artilleryman cradling the head of his dying horse. With its fundraising objective, the subject matter was undoubtedly designed to provoke an emotional reaction, and to modern tastes the picture can seem overly sentimental, an assessment shaped to some extent by its cloying 'matey' title. But its popularity was unprecedented. It was a picture which went straight to the hearts of the animal-loving British public, who seemed incapable of resisting its poignant charms. It is some testament to its enduring popularity that, more than fifteen years later, in November 1932, *The Sphere* announced, 'In response to many requests, a reprint of the striking picture has now been made in photogravure'. The prints were available for 5s or, for anyone wishing to secure the autograph of its famous creator, 10/6d for an artist-signed print. Today, *The Sphere* magazine is held as part of *The Illustrated London News* archive at historical specialist Mary Evans Picture Library. It is notable that, almost a century on, 'Goodbye, Old Man' remains the top-selling image on the company's print site. Interestingly, a week before the publication of Matania's John Cornwell image, they advised readers that the forthcoming picture would be a good 'companion piece' for 'Goodbye, Old Man'.

The years 1918 and 1919 saw Matania paint a number of pictures offering a conclusive end to *The Sphere*'s visual record of the war. There was a joyful composition of London in the throes of armistice celebrations, as well as more thoughtful or allegorical paintings on the themes of remembrance, including a moving impression of the Unknown Warrior being laid to rest in Westminster Cathedral on 11 November 1920. In 1919, *The Sphere* reported

WITH THE GUNS on the WESTERN FRONT.

The Proprietors of

THE SPHERE

have pleasure in announcing that at
an early date they will publish, in
PHOTOGRAVURE & COLOUR,

Mr. F. MATANIA'S Striking Picture

"GOOD-BYE, OLD MAN."

Particulars and Prices will be announced later.

Only a Limited Edition will be issued.

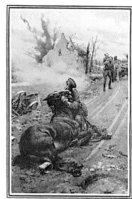

"GOOD-BYE, OLD MAN."
An Incident on the Road to a Battery Position in Southern Flanders.
Drawn by F. MATANIA, the famous "Sphere" Artist.

THE SPHERE & TATLER. Ltd., 6, GREAT NEW STREET, FETTER LANE, E C

that the original black and white drawing by Matania of John Buchan, VC, of the Argyll and Sutherland Highlanders had been mounted in a carved memorial together with the Army Order containing the account of his exploit. The memorial was gifted to Alloa Public Library from the town council in memory of the town's most gallant son.

Matania's career after the war continued apace, as befitted an artist of his stature and worldwide reputation. He had been elected to the Royal Institute of Painters in Water Colours in 1917 and frequently exhibited there. In total, he exhibited at the Royal Academy on ten occasions between 1908 and 1922, often only beginning the painting he intended to submit a few days beforehand. Other painters visited his studios to meet the maestro of realism and study his techniques, among them William Russell Flint and John Singer Sergeant, who owned one of his paintings (as did Queen Mary). Work for *The Sphere* continued and he turned his attention to recording the rapid changes afoot in post-war society, from the enfranchisement of women over 35 in

1918 to the discovery of the tomb of Tutankhamun in 1922. As reportage illustration gradually began to be displaced by photography in magazines, his agents Rogers and Co. of Chancery Lane still found him plenty of regular work. Among his many commissions were a number of railway posters, travel and hotel brochures, illustrations for Spode's bicentenary and a series of advertisements for Ovaltine and classic clothing brand Burberry.

Following the highs of First World War reporting, Matania felt the subjects he was asked to cover in peacetime could not compare: 'After it was over I realised drawings of innocuous functions would not appeal, photography had made great strides so I turned to something else, the reconstruction of historical events.'

In 1929, he began to illustrate a series of stories from the past for a new women's magazine, *Britannia and Eve*. The title, which was in the same publishing stable as *The Sphere* (now affiliated to the *ILN* under the umbrella of Illustrated Newspapers Ltd), attracted a number of prestigious contributors including Daphne du Maurier and Agatha Christie. Matania's first task was to provide pictures for a series written by Kenneth Bell looking at 'Famous Women of History', beginning with Helen of Troy and following on with such feminine icons as Sappho and Messalina. A year later, he was illustrating 'Tragic and Comic Stories from History' by Norman Hill. Having proved his penmanship in the past, Matania began to illustrate *and* write for *Britannia and Eve* himself, beginning in January 1933 with a series entitled 'Strange Chapters from History'. 'Queer Tales of Long Ago' followed in 1934 until, eventually, the magazine settled on 'Old Stories Re-told', which, despite an original plan for the series to run for six months, Matania would write and illustrate for almost two decades. Here was an opportunity for him to indulge his love of history, particularly as he was given complete freedom to pick and choose his monthly subjects. As ever, quality of illustration and attention to detail was exemplary, though his enthusiasm for presenting female characters in varying states of undress showed a new side to the artist – one where the costumes and settings were correct, but the scenarios were embellished by fantasy. Matania was allowing his quest for historical truthfulness to be blurred slightly by the application of artistic licence, well aware perhaps

'Pro Italia' – Allies and Brothers-In-Arms for Justice. This picture was drawn by Matania for Italian Day on 7 October 1915 and disposed of in the streets in the form of a souvenir pocket handkerchief. The original drawing, which was also reproduced on *The Sphere*'s cover on 28 September that year, is owned by the Italian Red Cross Society.

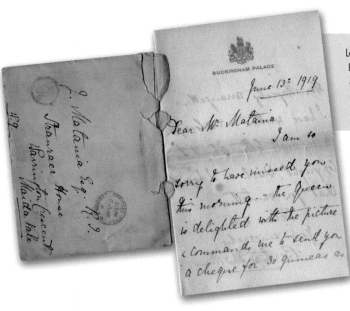

Letter from Buckingham Palace dated 13 June 1919, documenting Matania's sale of one of his paintings to Queen Mary.

that these pictures were illustrating stories designed to entertain as well as inform. When questioned about his propensity to paint the past with more bare flesh than was probably historically correct, he would protest that it was what circulation-hungry editors repeatedly requested of him. Matania's love of painting the female form is clear to see. A British Pathé newsreel from 1932 shows him mischievously flirting with the skimpily clad models in his studio, and it comes as no surprise to discover via one contemporary newspaper report that he was one of the judges at a Miss Europe competition in 1937. Indeed, one of his favourite paintings ~ 1923's 'The Bath', featuring a number of fleshy figures at a Roman Baths ~ was one of the few paintings he never parted with. He and three models had worked unceasingly to complete the picture over a two-month period and although he claimed he was 'as a corpse taken to the cemetery' after its completion, he declared, 'Even if I am starving, I will not sell it.'

The picture is a gorgeous homage to the female nude. 'My art is dedicated to women,' he told Kenneth Allsop, who interviewed him for *Picture Post*

magazine in 1951, 'They have been my inspiration – a mother, a sweetheart, a wife.' Interestingly, in later life Matania formed a friendship with the artist Norman Pett, creator of the Second World War strip cartoon character Jane, who sent Matania Christmas cards decorated with his curvaceous pin-ups. The two men clearly shared some aesthetic common ground. Matania's historical women, from Cleopatra to Boadicea, are voluptuous and Junoesque, shimmying in their togas and straining in their corsets, but this titillation of history seemed to suit the magazine's readership. This was the age of the biblical epic movie and the sensational novel. On reflection, Matania's bodice-ripping subjects were more in tune with the tastes of the time than we might believe.

'Old Stories Re-Told' saw him settle into working in the historical oeuvre. His studio was a fantastical cave of architectural and decorative props, most of which were constructed by Matania himself. His second wife Goldie was one of his most regular models, and dressed in a succession of lavish costumes from Roman togas to Renaissance gowns in order to achieve absolute historical authenticity. Matania also used two mannequins, one of which he had picked up at Caledonian Road antiques and bric-a-brac market, a treasure trove for many of his props. Goldie's grandson Harry Nockolds recalls visiting 'Mr Matt's' studio as a young boy and being endlessly fascinated by the theatrical surroundings. There would be

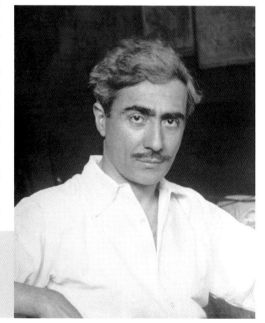

Fortunino Matania, pictured around the 1920s. His Mediterranean good looks and confident charm no doubt came in useful on numerous occasions during his career.

the sounds of music lessons given upstairs by Mr Matt's brother, who was a musician, while the artist himself he remembers as a small man, still handsome despite his advancing years, his black wavy hair turned to snowy white, and always warm, charming and vital.

Matania's pictures were syndicated to a number of popular magazines, including *Everybody's Magazine*, *Picture Post* and, in his twilight years, the children's educational magazine *Look and Learn*, for whom he illustrated a number of historically themed serials (he was working on 'A Pageant of Kings' for the paper when he died). His renown for historical reconstruction also led to him providing artwork for a number of Hollywood movies, including Cecil B. De Mille's *The Ten Commandments* in 1923 and the 1934 film *The Man Who Knew Too Much*, directed by Alfred Hitchcock.

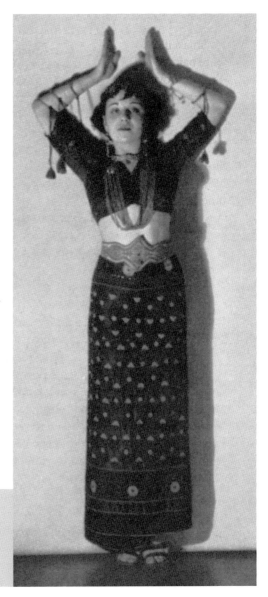

Artistic talent and creativity ran through the veins of the Matania family. Fortunino's daughter Clelia (1918–81), pictured here in the costume of an Arabian dancer in a 1934 issue of *The Sphere*, went on to have a successful career as a character actress.

This book brings together for the first time a wide selection of Fortunino Matania's illustrations from the First World War, the vast majority of which were painted specifically for, and published in, *The Sphere*. The subjects are diverse, moving the viewer from the mobilisation of troops in the early weeks of the war to the appalling reality of gas attacks suffered in the trenches; desperate hand-to-hand fighting and valiant Victoria Cross actions to moments of quiet contemplation ~ and occasionally fun ~ away from the front line. The home front is not forgotten and nor are the other arenas of conflict ~ the Eastern Front, Italy (unsurprisingly) and sea battles all have been brought to life by Matania's brush. *The Sphere* was justly proud of its star artist. In a wartime advertisement for the magazine, it waxed lyrical on his peerless work:

> Drawings by Signor Matania made with the knowledge which comes from actual experience in the trenches and elsewhere at the Front in France, have been pronounced to be the most lifelike, the most graphic and the most realistic which have yet been published in this great struggle.

It was also obliged to defend him in the face of doubt over the veracity of such illustrations. Of the picture 'An Incident on the Road to Lassinguy: The Charge of the French Light Cavalry', published on 10 October 1914, *The Sphere* wrote:

> This, in common with all 'The Sphere' pictures, is no mere fancy sketch of the kind which justified the assertion of 'The Daily Telegraph', that war pictures have no relation to accuracy. Every detail of the above drawings is guaranteed to be severely accurate.

On another occasion, Clement Shorter once again emphasised the extreme lengths his artist went to in order to achieve his pictures:

> During the course of the war, Mr. Matania has been out to the Western front as special artist for *The Sphere*, and as evidence of the nearness of his view point to the actual fighting line, it may be mentioned that while he has been

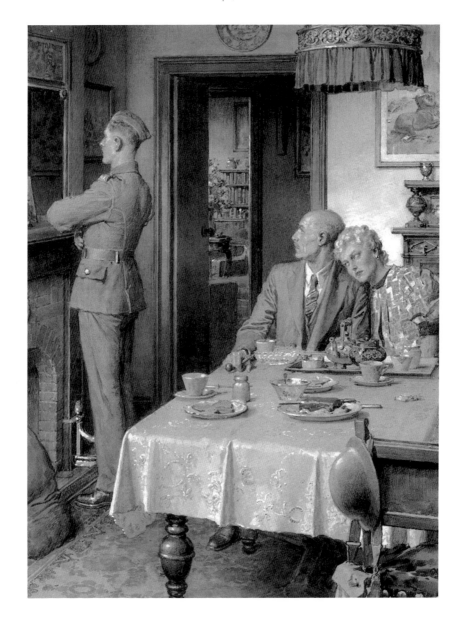

sketching in the trenches, shells have burst in close proximity … This knowledge of the actual conditions of the fighting zone combined with an exceptional artistic memory, gives a special value to all Mr. Matania's war work.

Matania's work was known way beyond Britain. His pictures were syndicated far and wide in his lifetime, published in weekly magazines, newspapers and children's books around the world. He was an artist who was seen by literally tens of millions of people. Having achieved such familiarity and fame makes his relative obscurity in the twenty-first century all the more perplexing.

The Times review of Matania's Royal Academy picture in 1918 gives us one hint – the writer refers to his painting as a 'mere illustration'. Another clue lies with the Imperial War Museum, who declined his Neuve Chapelle picture in 1922 and, according to their records, hold just one painting, 'The

Opposite: Just twenty-one years after the war to end all wars, Europe once more erupted into conflict. Matania was still actively painting and produced a number of pictures for *The Sphere* during the Second World War. Entitled 'The War Baby', this picture of a young man born during the First World War and now preparing to fight in the second was published in *The Sphere* on 30 September 1939. All the familiar Matania hallmarks are there, from the perfect rendering of the starched, embroidered tablecloth to the distraught expressions on the faces of the soldier's parents. Note the picture hanging on the wall, Matania's own most famous image of the First World War – 'Goodbye, Old Man' – an emotive device and a link between the two generations to fight in world wars. (*The Sphere*, 30 September 1939)

Right: Self-portrait in charcoal, *c.* 1950s.

Last Message', which was gifted by the artist in 1957. The distinguished military historian, Dr John Laffin, did not disguise his admiration of Matania in his 1991 book *The Western Front Illustrated 1914–1918*. In it, he also relates a conversation he had about war illustrators with a retired senior official of the Imperial War Museum. When he put forward the point that the work of war illustrators, despite their skill and accuracy, was so little regarded as a serious testimony of the war, the reply was dismissive: 'They were merely illustrators, not real artists, so they can't be taken seriously.' Matania, despite widespread admiration by many great artists in his lifetime, has been relegated to a division several rungs below them, his realistic style considered unfashionable and unimaginative. But Singer Sargent's admiration and subsequent purchase of a painting in 1915 reminds us that he rated Matania highly, regardless of whether his work was fashionable. Matania was, first and foremost, an illustrator and was never too proud to take on commercial work. His art was commissioned, he was given a brief, he produced

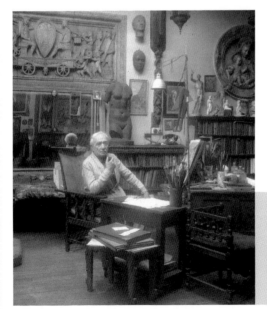

the work and he was paid (handsomely) for the finished picture. Matania did not generally paint 'art for art's sake', though he undoubtedly adored his occupation and felt it a natural calling. Ironically, it was work as a commercial artist, or, more specifically, as a magazine artist, that led to a far wider dissemination of his art among the public.

Fortunino Matania pictured in later life in his studio, surrounded by handmade props and reproduction architectural pieces, many of which he constructed himself. These helped Matania achieve the authentic historical detail which was to be the hallmark of his work.

It is worth considering that more people, both in Britain and in other countries, would have been familiar with the art of Fortunino Matania than with the Impressionists. Matania, interviewed in the *Picture Post* in the 1950s, had his own strident opinions on the subject of modern art:

> Cezanne? Picasso? Frauds! They have left the road to beauty. They have spoiled young minds. But it will all end in laughter. Those paintings will one day be in museums, like ancient instruments of torture, to show the depths to which art fell.

It is a further irony that his prediction was so utterly misjudged, but his comments were not the result of arrogance or pompous grandstanding. Kenneth Allsop acknowledged Matania's timeless appeal and disregard for fashion, writing:

> It would be easy for the critic to damn a man who condemns, as imbecilic, attempts to wrestle forward towards new planes of expression; but contentment with his method has not been an easy commercial dodge for Matania. Showing me his studio, he asked: 'Could conscience go further?' It could not, for in that fusion of laboratory and museum are his 'props': the statuettes and column, the vessels and thrones, the lamps and costumes – replicas made by himself and entailing years of research.

Matania is not to everyone's taste. His literal depictions of actual events, though impressive as documents of social, military and political history, are not necessarily the kind of pictures people wish to hang on their walls at home (with the exception of 'Goodbye, Old Man', which attracts devotees to this day). The subjects can sometimes be harrowing and challenging (though frequently beautiful) and despite Matania's loyalty to true-life events as he understood them, it was impossible for his wartime pictures not to display an undisguised bias towards Allied superiority, a suggestion that sometimes sits uncomfortably with our modern-day sensibilities. His monochrome pictures (comprising the larger proportion of

his work) have a refined grace and finesse, but Matania could occasionally verge on gaudy when working in colour. Perhaps it is unsurprising in an artist whose pictures so many likened to photographs; Matania's monochrome paintings exhibit the same classic elegance produced by black-and-white photography.

Whatever your own aesthetic preferences, Matania's pictures, and particularly his First World War images, retain a magnetism that is incredibly hard to resist. The photo-realist style provokes gasps of admiration; the highly charged situations draw comment and empathy. It is as if Matania is inviting us along on his visits to the front and for any history enthusiast, this time travelling tour through the battlefields, dug-outs and factories of Great War Britain, is an insightful and educational experience. His body of work for *The Sphere* – formed of literally hundreds of illustrations – is astounding not only for its detail and breathtakingly realistic style but also for its sheer volume. Firmly rooted in the traditions of illustrated journalism, Matania knew how to work to deadlines; a skill he had honed as an apprentice in his father's Naples studio back in the 1890s, but his ability to churn out such highly complex, superbly executed pictures in a matter of days was an accomplishment verging on the miraculous.

Painter, perfectionist, historian, craftsman, war correspondent, writer, raconteur, showman – Fortunino Matania was all these things. Some may also wish to add genius to that list. Certainly, within his own sphere of activity, this 'mere' illustrator was in a class of his own. One hundred years on, Matania's vision of the First World War, in all its rich detail and drama, remains an impressive memorial to those who fought and lived through that tumultuous time.

Opposite: 'A Detachment of Uhlans Encountering Barbed-Wire Defences Outside Liège.' This was Matania's first cover image of the war and shows a detachment of Uhlans charging down a Liège fort, only to find itself entrapped amongst the barbed-wire defences which had been constructed at strategic points. The composition of this image is very similar to the one showcased in Percy Bradshaw's portfolio on Matania. (*The Sphere*, 15 August 1914)

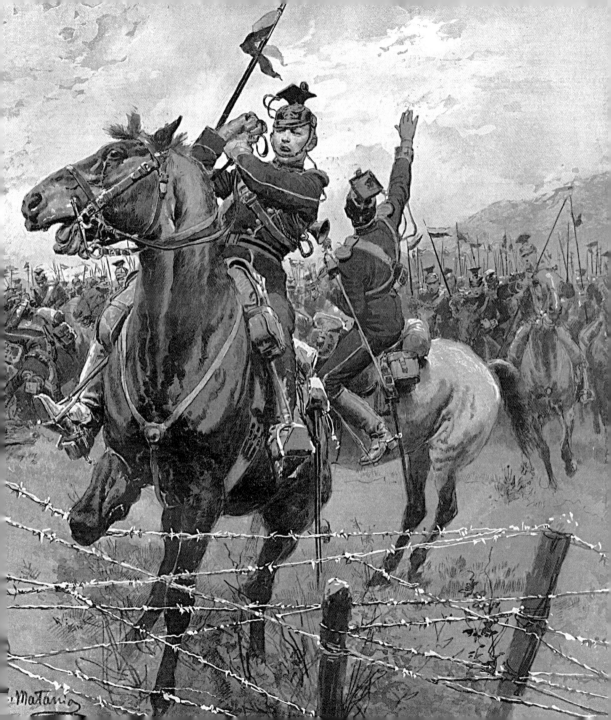

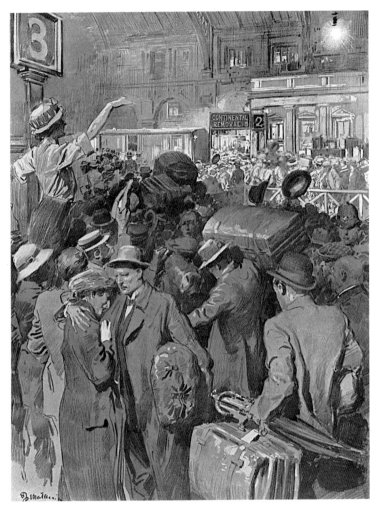

'The Armageddon Reservists Leaving London.' German reservists leaving London from Victoria Station, destined for Queenborough in Kent, where they would depart for Flushing (now Vlissingen) in Holland. There were 35,000 Germans living in Britain when Germany declared war on Russia on 1 August 1914 and those who answered the call of their country often left behind families in Britain. Many preparing to leave were detained under the Aliens Restriction Act, which was hastily passed by Parliament on 5 August. (*The Sphere*, 15 August 1914)

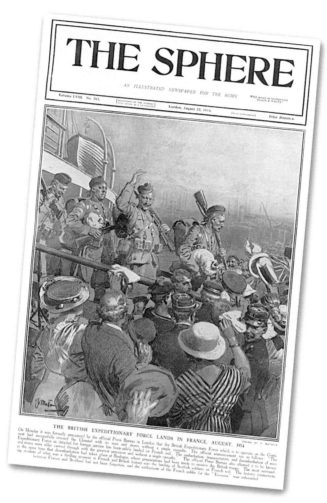

'The British Expeditionary Force Lands in France, August 1914.' Scottish soldiers disembarking in Boulogne receive a warm welcome from the French. *The Sphere* commented, 'The historic connections between France and Scotland had not been forgotten, and the enthusiasm of the French public for the "Ecossais" was unbounded'. News that the British Expeditionary Force had crossed the Channel was only released on Monday 17 August and with such a short time to complete his painting before *The Sphere*'s presses rolled, it is forgivable that Matania's cover image does not have his usual polished finish. (*The Sphere*, 22 August 1914)

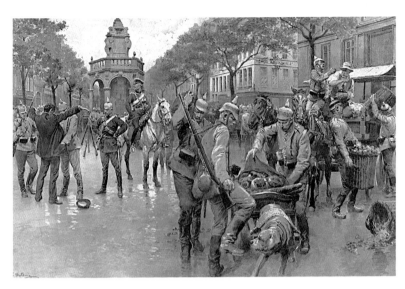

'The Germans in Liège: Within the Marketplace of the Busy City of the Walloons.' German soldiers pictured helping themselves to produce from market stalls in the Place du Marché in Liège. The Battle of Liège was the opening engagement of the German invasion of Belgium and the first battle of the war. The length of the siege of Liège may have delayed the German invasion of France by four to five days. (*The Sphere*, 22 August 1914)

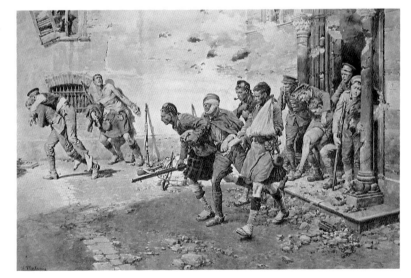

'A Dramatic and Pathetic Episode in the Famous Four Days' Retreat from Mons.' Matania interviewed a wounded soldier in order to gather information for this picture, which shows wounded soldiers evacuating a small church after it had been shelled by the Germans, despite, *The Sphere* remarks pointedly, the presence of the Red Cross flag flying from its roof. (Original monochrome gouache, reproduced in *The Sphere*, 26 September 1914)

'Cossacks of the Russian Army Charging the German Death's Head Hussars at Schwansfeld' (now in Poland), between Korschen and Bartenstein in East Prussia. The Germans were routed. The rapid mobilisation of the British Expeditionary Force, and its success in halting the German advance through Belgium into France, led to the failure of the famed Schlieffen Plan and left Germany fighting a war on two fronts in 1914. (*The Sphere*, 3 October 1914)

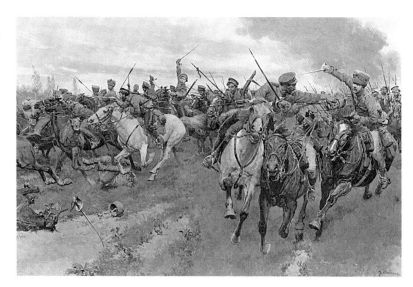

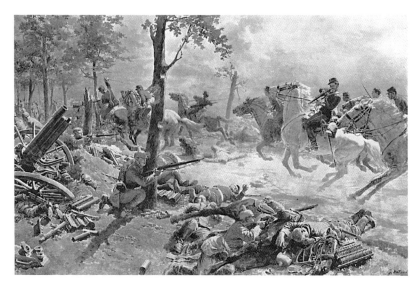

'The Charge of the French Light Cavalry against the Germans on the Road to Lassigny' (a village between Montvidier and Noyon in France). Matania's first visit to the front was not until the spring of 1915. This picture was painted using information supplied by Harold Ashton, correspondent for *The Daily News*. (*The Sphere*, 10 October 1914)

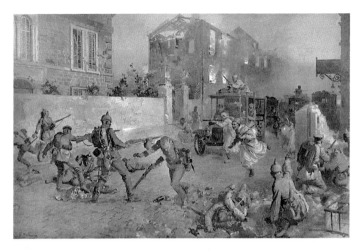

'The Taxicab in War – An Exciting Incident in the Town of Senlis.' German occupiers of Senlis in Picardy, who, according to *The Sphere* caption, had burnt down many buildings and shot the mayor and two other dignitaries, are surprised by a dash of Turcos (native French colonial Algerian troops) whirling into the town in taxicabs. (*The Sphere*, 17 October 1914)

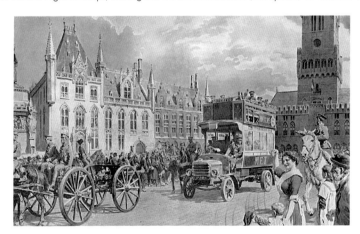

'British Troops Passing Across the Grand Place at Bruges During the Retirement of the Belgian Army from Antwerp.' Matania's image was based on a sketch done in Bruges by the sculptor Jo Davidson, who commented of the scene: 'It was a very extraordinary sight to see the British Tommies outlined against the quaint Flemish architecture of Bruges, and the London omnibuses, too, seemed strange. But it was good to see it.' (*The Sphere*, 31 October 1914)

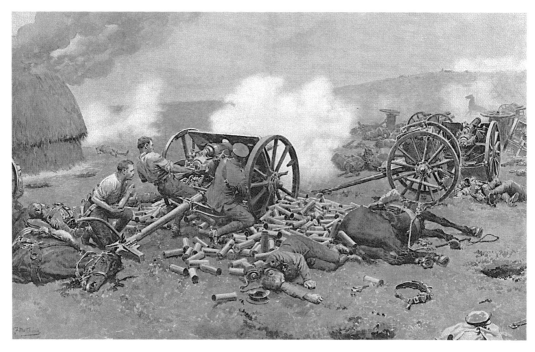

'How Three Gunners of 'L' Battery won their V.C.' On the morning of 1 September 1914, 'L' Battery of the Royal Horse Artillery were surprised by the German 4th Cavalry Division, twice the size of the British, who launched an attack near the village of Néry. Within minutes all of the British guns were put out of action, save for a 13-pounder manned by Captain Bradbury, Sergeant-Major Dorrell, Sergeant Nelson and Gunners Osborne and Derbyshire, a heroic stand that allowed the 1st Cavalry Brigade to counterattack. Bradbury, Dorrell and Nelson were all awarded the Victoria Cross – Bradbury posthumously. Derbyshire and Osborne were awarded the Médaille Militaire. The *Daily Telegraph* called it 'An incident which will go down into history as one of the grandest incidents of British bravery in the face of apparently overwhelming odds'. Matania's impression of the action was supplemented by a diagram of the almost wholly destroyed battery, drawn by his cousin Ugo. (*The Sphere*, 14 November 1914)

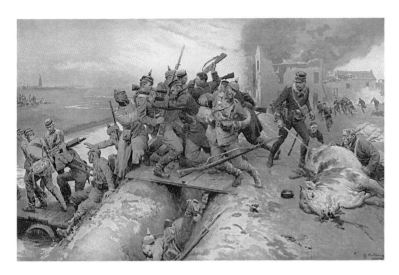

'The Desperate Struggle of the Germans for the Yser Canal.' A struggle between German and Belgian troops, with dense and close-packed fighting, described by a Belgian soldier, Private Alexandre Gosselain, who was wounded during the action and recovering in the London Hospital. A number of cows to the right of the picture have been killed by shell fire, and a Belgian marksman positions himself behind one of the fallen animals for protection as he fires on the advancing Germans. (*The Sphere*, 21 November 1914)

'Winter Conditions in the Yser Country: How the Cold is Affecting Friend and Foe.' British soldiers with German prisoners united in their fight against the cold weather. *The Times* remarked, 'Only last week the air was warm and soft and still, and the Belgian soldiers were bathing in the Nieuport-Ypres canal, while the smoke of the bursting shells hung motionless in the windless atmosphere. To-day there is a driving blizzard and the roads are turned into channels of mud.' (*The Sphere*, 5 December 1914)

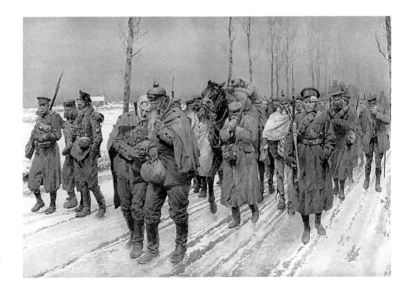

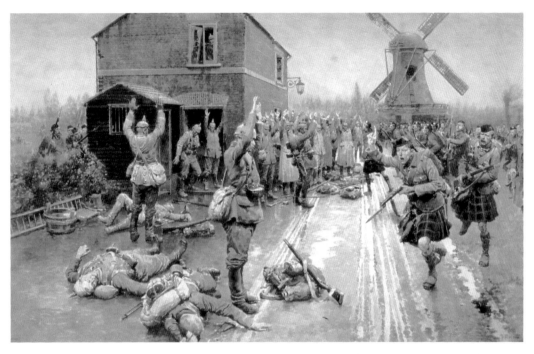

'"Hands up!" The Capture of a German Force near Langemarck by the Cameron Highlanders.' An incident personally recounted to Matania by Private A.H. Beard, who was wounded in the engagement which took place on 23 October 1914. (Original artwork reproduced in *The Sphere*, 12 December 1914)

'The King Upon the Battlefield – Examing the Last Memorials of the Fallen.' King George V, accompanied by his eldest son the Prince of Wales, pays his respects at the grave of a fallen soldier during his first visit to the front in December 1914. (*The Sphere* front cover, 19 December 1914)

'Abuse of the White Flag – An Incident Showing how our Men Were Cut Down by an Ambushed Enemy.' The commonly accepted belief in German perfidy and unsporting behaviour were common themes for illustrators. In this example, in an incident that occurred near Troyon in September 1914, the enemy feigned surrender to A Company of the Northamptonshire Regiment. On their rising to accept the surrender, a second line of German infantry suddenly made an appearance and the company 'suffered heavy losses before help could arrive'. (*The Sphere*, 2 January 1915)

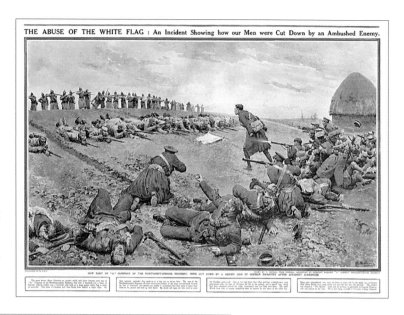

THE ABUSE OF THE WHITE FLAG : An Incident Showing how our Men were Cut Down by an Ambushed Enemy.

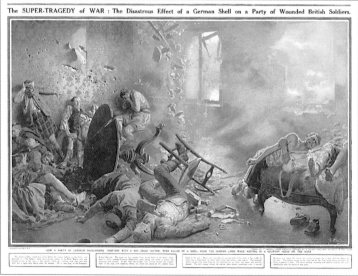

The SUPER-TRAGEDY of WAR : The Disastrous Effect of a German Shell on a Party of Wounded British Soldiers.

'The Super-Tragedy of War: The Disastrous Effect of a German Shell on a Party of Wounded British Soldiers.' This incident was described by a private soldier of the Black Watch who was in the room a few moments before a shell explosion. The scene shows a shell from the German lines coming through the window and bursting in the room with disastrous effects, a doctor and nearly all the soldiers being killed on the spot. Matania's handling of the explosion itself is exemplary, and although not overly graphic, the picture is a chilling record of the damage that could be done by shell blasts. (*The Sphere*, 9 January 1915)

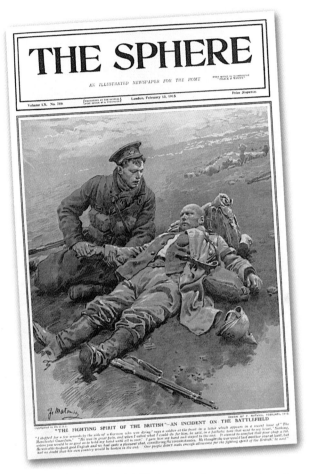

'"The Fighting Spirit of the British": An Incident on the Battlefield.' Matania's illustration was based on a letter sent to the *Manchester Guardian* by a British soldier who gave an account of his time spent with the enemy: 'I stopped for a few seconds by the side of a German who was dying. He was in great pain, and when I asked what I could do for him, he said, in a pathetic tone that went to my heart, "Nothing, unless you would be so good as to hold my hand until all is over". I gave him my hand and stayed to the end. It seemed to comfort that poor chap a lot. He was able to speak good English and we had quite a pleasant chat, considering the circumstances. He thought the war would last another year at least, but had no doubt that his own country would be beaten in the end. "Our people didn't make enough allowance for the fighting spirit of the British" he said.' (*The Sphere*, 13 February 1915)

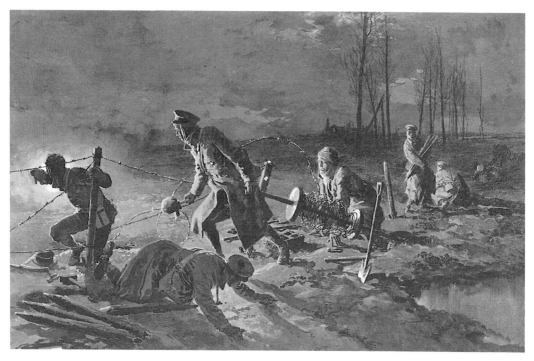

'In No Man's Land: The Dread Territory which Belongs to Neither German nor Briton.' Royal engineers working in the dark of no-man's-land to construct barbed-wire barriers in front of British trenches are exposed by German magnesium flares, giving this illustration a Caravaggioesque quality. Such work was extremely risky, or 'nervy', as one Royal Engineer described it to *The Times*. He went on to say, '...it is done in the open and out of the kindly cover afforded by a trench ... fortunate indeed is the working party if the enemy does not hear the sound of the picket being driven into the ground and open fire ...' Flares lasted for fifteen seconds, an eternity for men who had to throw themselves flat to the ground and lie inert until darkness returned. (*The Sphere*, 13 February 1915)

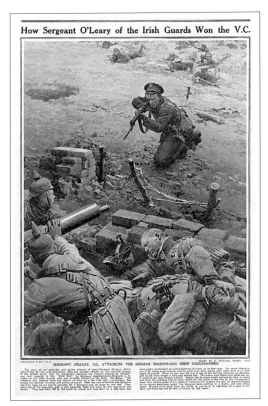

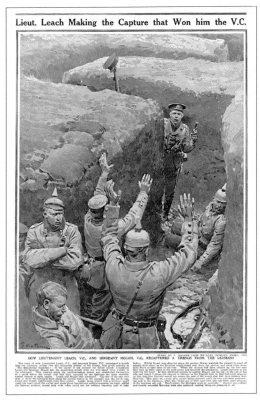

'How Sergeant O'Leary of the Irish Guards won the V.C.' The bravery of Lance-Corporal Michael O'Leary was to make him one of the most famous VC winners of the war and it was only natural that the most famous artist of the war should record his actions for posterity. In a localised operation near the French village of Cuinchy, O'Leary ran ahead of the rest of his assault party and, on reaching the German barricades, killed all five of the machine-gun crew before charging forward and taking a second machine gun position. (*The Sphere*, 13 March 1915)

'Lieut. Leach Making the Capture that Won him the V.C.' Lieutenant James Leach and Sergeant John Hogan of the Manchester Regiment recapturing a trench near Festubert from German occupation and in the course of doing so earning Victoria Crosses. Matania's picture was based on a report of the incident in the *Manchester Guardian*. (*The Sphere*, 13 March 1915)

'The Care of the Wounded War-Horse in the Northern France: What is Being Done to Alleviate the Suffering of Dumb Animals in the War Region.' The work of the Blue Cross at the front – veterinary doctors receiving a wounded war horse for treatment at a Blue Cross Station or receiving depot. (Original artwork, reproduced in *The Sphere*, 27 February 1915)

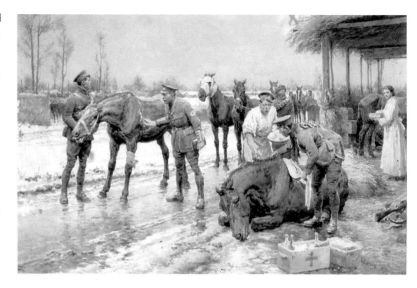

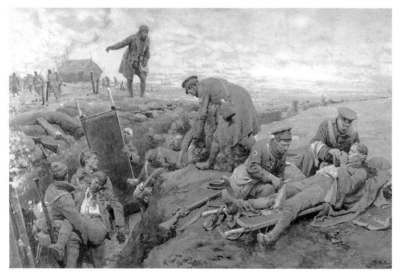

'The Work of the Royal Army Medical Corps: First Aid in the Trenches.' Royal Army Medical Corps orderlies gathering the wounded from a British trench after a successful advance. Matania painted this according to a personal description given by Sir Frederick Treves. (Original artwork reproduced in *The Sphere*, 6 March 1915)

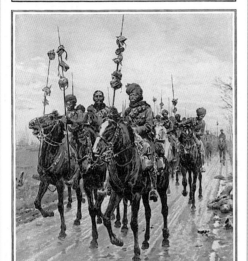

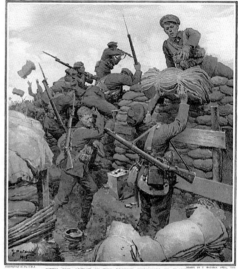

'Bengal Lancers Returning from "Port Arthur" after the Capture of Neuve Chapelle.' Bengal Lancers, with a number of German helmets impaled on their lances, ride home from 'Port Arthur'. The Battle of Neuve Chapelle, which took place between 10 and 12 March 1915, was the first set-piece offensive battle undertaken by the British from static trench lines. Indian soldiers made up about half of the attacking force and suffered heavy losses, nevertheless capturing significant sectors along the German line. The Indian Memorial at Neuve Chapelle commemorates the 4,700 Indian soldiers and labourers who lost their lives on the Western Front. (*The Sphere*, 10 April 1915)

'With Our Artist on the Western Front.' With an order to advance given, British soldiers scramble out of their trench to move forward and occupy a captured German trench. Equally important, and shown here, is the movement of sand bags along with men in order to reconstruct a rearward-facing aspect to create protection. One of a number of illustrations done by Matania while on his visit to the front in the spring of 1915. (*The Sphere*, 1 May 1915)

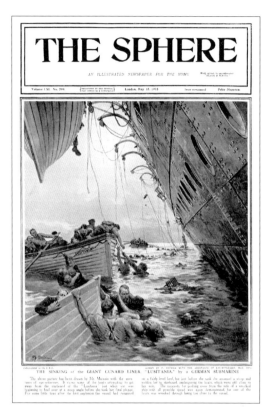

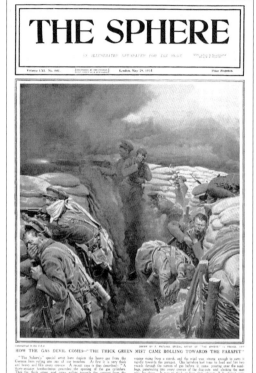

'The Sinking of the Giant Cunard Liner, "*Lusitania*", by a German Submarine.' The sinking of the *Lusitania* by a single torpedo fired from the German U-boat U-20 on 7 May 1915 provoked outrage from the public in Britain and the United States. The ship sank in eighteen minutes with the loss of almost 1,200 lives, many of them British and American civilians, although claims that the liner was carrying ammunition in its cargo, denied for decades, have since been proved correct. Matania, who painted his version with the help of eyewitness accounts, managed to convey the fear and panic of the civilian passengers while also providing an accurate record of the event. (*The Sphere*, 15 May, 1915)

'How the Gas Devil Comes – "Thick green mist came rolling towards the parapet".' On 22 April 1915 at Ypres, the Germans used poisonous chlorine gas for the first time. Despite warnings from captured Germans, the British and French were totally unprepared and, with no protection, began to suffer the effects within minutes – hundreds died. The British press was outraged at this new, insidious form of warfare perpetrated by the Germans. Sir John French reported of the use: 'The quantity used produced long and deliberate preparation for the employment of devices contrary to the terms of the Hague Convention, to which the enemy subscribed.' (*The Sphere*, 29 May 1915)

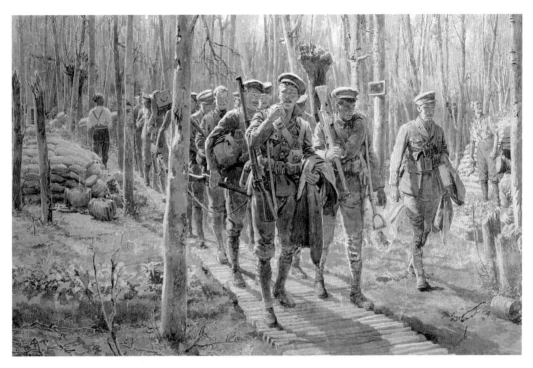

'In the Famous "Plug Street" Wood – A Relief Party Marching Back to the Trenches through "Regent Street".' Painted by Matania from first-hand experience during his 1915 visit to the front, this picture is of 'Plug Street' Wood – a British colloquialism for Ploegsteert Wood – south of the Ypres salient. Although a quiet spot, many died from isolated shelling and sniping, evidence of which can be clearly seen on the scarred trees. (Original monochrome artwork, *The Sphere* 29 May 1915)

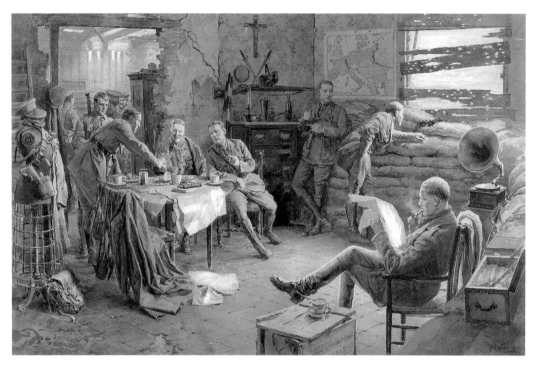

'With the British Officer in the Ypres Salient: Afternoon Tea in a Ruined Farmstead behind the British Lines in the Ypres District.'
British tradition alive and well in a ruined farmhouse, as witnessed by Matania during his visit to the front in spring 1915.
He gave a description in the same issue which emphasises the incongruity of such civilised behaviour amid the ever-present
dangers at the front: 'The maps are swept away to make room for cups, jam, and bread and butter, while the officers neglect
nothing which can complete the table. Conversation over the tea cups begins with the same characteristics which you would
hear in a Kensington drawing-room. Sammarco from a gramophone sings the "Tremenda Vendetta" from Rigoletto, while outside
the terrific bursting of shell shakes the walls and rattles the tea cups. An accomplished officer asks me for a second time, "How
many lumps of sugar?"' (Original monochrome artwork reproduced in *The Sphere*, 5 June 1915)

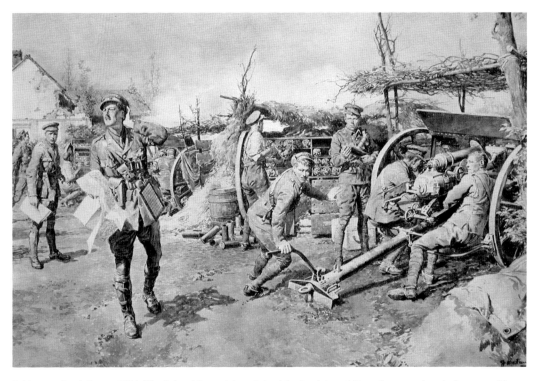

'A Visit to a British Battery: With "The Sphere" Special Artist Behind the British Lines.' 'An order arrives by telephone; a soldier repeats it loudly; the officer unfolds his map hurriedly and looks, and raps out, "Tell the observer we will fire on X".' Matania spent time with an artillery battery and was awestruck by the number of personnel involved in feeding the guns and ensuring they met their target. In his account published in *The Sphere* he noticed that the bombardment stopped due to an obvious lack of shells. His voice was one of many who commented on the so-called 'shell scandal' of that year, writing that he 'wondered why the bronze mouths hungered so for their daily food'. (*The Sphere*, 26 June 1915)

'The Communication Trench: Its Sporting Nature as Experienced by "The Sphere's" Special Artist at the Front.' Matania passed along this trench during his visit to the front: 'The sniper is a constant danger, and cover from the enemy's bullets scanty … It is a long double wall of sandbags from 3ft to 4ft high … The height of the sandbags renders it advisable to proceed in a stooping fashion, bent almost double … Soldiers are passing or repassing, perspiring, laughing, joking, and teasing one another, whilst every now and then the noise is drowned by a voice, "Keep your head down, you d____d fool!"' (*The Sphere*, 10 July 1915)

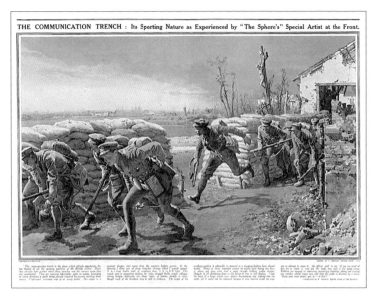

THE COMMUNICATION TRENCH : Its Sporting Nature as Experienced by "The Sphere's" Special Artist at the Front.

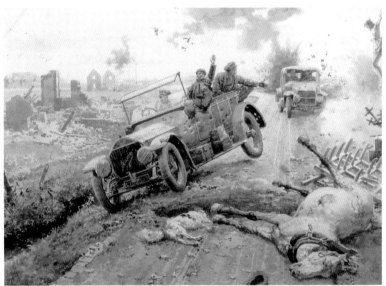

'The Staff Car and its Daily Work: An Ordinary Episode during a Bombardment.' Another hair-raising experience for Matania in which a staff car had to swerve to avoid a shell crater in the road, beside which a horse and dog laid dead. 'As we dashed towards the grass … I held my breath. For a moment or two we seemed in the air. The car left the road, her off wheels skimming over the crater just formed by the shell. Then with a little jerk we were on the road again.' (Original artwork reproduced in *The Sphere*, 18 September 1915)

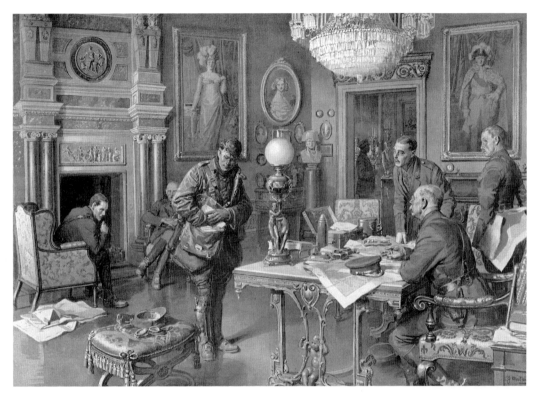

'How Staff are Informed of Movements at the Front.' From the roar and 'excitement' of the trenches to the peaceful calm of a French chateau – a despatch rider at British headquarters brings reports from the fighting line. The term 'chateau generalship' has sprung out of the lexicon of the First World War, suggesting that those in command were out of touch with what was happening on the front line some distance away. In reality, brigades and divisions needed headquarters and large houses and chateaux were a practical choice. Matania witnessed the comparative luxury enjoyed by those at headquarters, 'where in some magnificent castle, in some salon of the Empire period, a worthy background is found for the elegant officer in khaki.' (*The Sphere*, 9 October 1915)

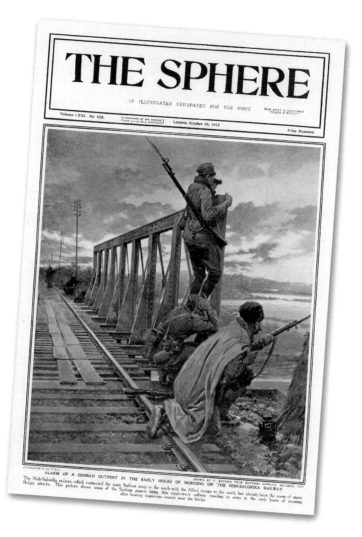

'Alarm on a Serbian Outpost in the Early Hours of Morning on the Nish-Salonika Railway.' This atmospheric front cover by Matania depicts a remote-looking Serbian outpost on a single track railway bridge on the Nish-Salonika Railway. Having been the scene of recent Bulgar attacks, the guards stand to arms when they hear suspicious sounds. (*The Sphere*, 30 October 1915)

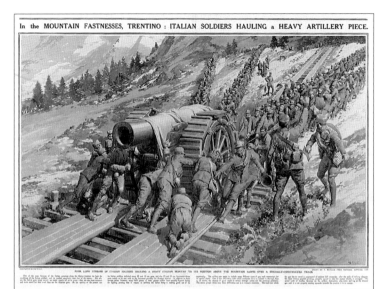

In the MOUNTAIN FASTNESSES, TRENTINO : ITALIAN SOLDIERS HAULING a HEAVY ARTILLERY PIECE.

'In the Mountain Fastnesses, Trentino: Italian Soldiers Hauling a Heavy Artillery Piece.' A heavy Italian mortar is hauled into position up a mountain slope using a specially constructed track in the province of Trentino on the border of Austria-Hungary. (*The Sphere*, 6 November 1915)

'Development of Trench Warfare in France.' Although the First World War was fought on many fronts, it would be symbolised for many by the trench of the Western Front. By November 1915, Matania was picturing the defensive fortifications that were to become typical. The French soldiers undergoing heavy bombardment by the enemy here are wearing the new steel helmets. (*The Sphere*, 20 November 1915)

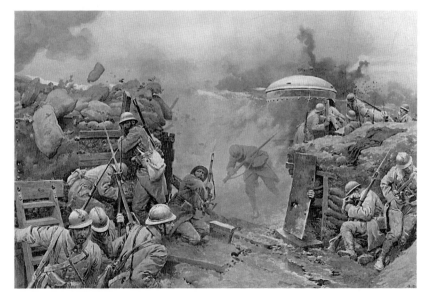

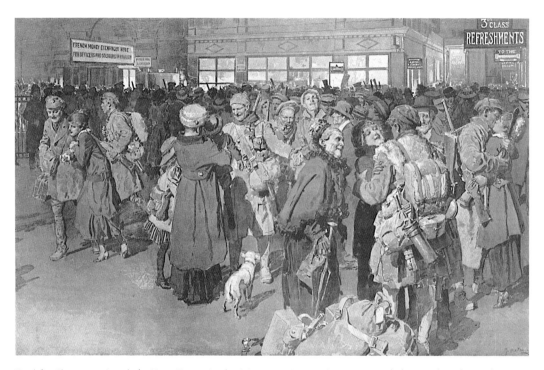

'Back for Christmas – Arrival of a Troop Train in London.' A scene at Victoria Station, as men lucky enough to obtain Christmas leave are met by families and sweethearts in a bittersweet portrayal of reunion, observed by Matania, who noted that many still 'had the mud of Flanders still caked upon them'. Train stations, Victoria in particular, were thronged with soldiers coming and going throughout the year but *The Times* reported of exceptional 'turmoil' during Christmas 1915 and described it as 'a place of a good deal of emotional experience in these days. The observer feels compelled to watch; and yet from so much of it he feels compelled also to turn away his eyes.' (*The Sphere*, 18 December 1915)

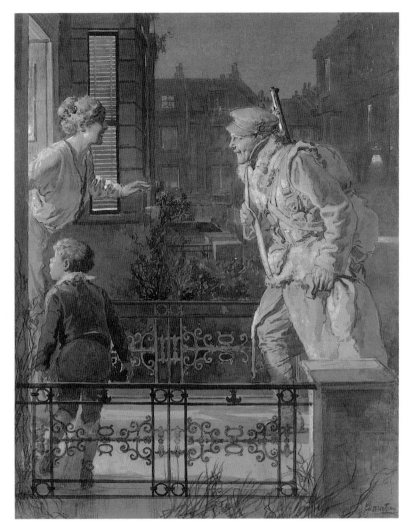

'Home for Christmas: A Real Santa Claus at the Door.' Many surprise visits from the trenches characterised the Christmas of 1915. Owing to late arrivals and closed post offices, men were not able to let their families know of their impending return. This returning warrior is bathed in light as his wife and son open the door to him, making for a magical and uplifting wartime Christmas scene by Matania. (Original monochrome artwork reproduced in *The Sphere*, 1 January 1916)

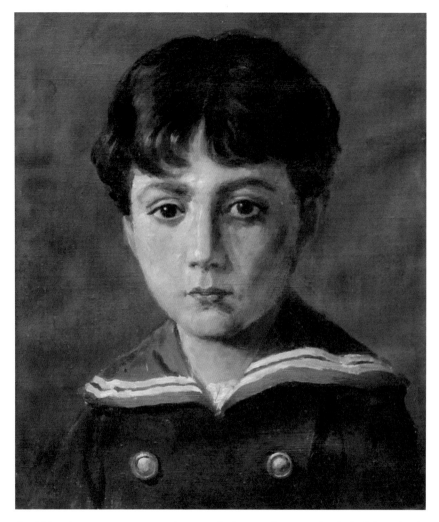

The child prodigy. Fortunino as a young boy. Copy by the artist of a portrait done by his father, Eduardo.

Matania was just 12 years old when he painted this accomplished vignette portrait of his father Eduardo at work.

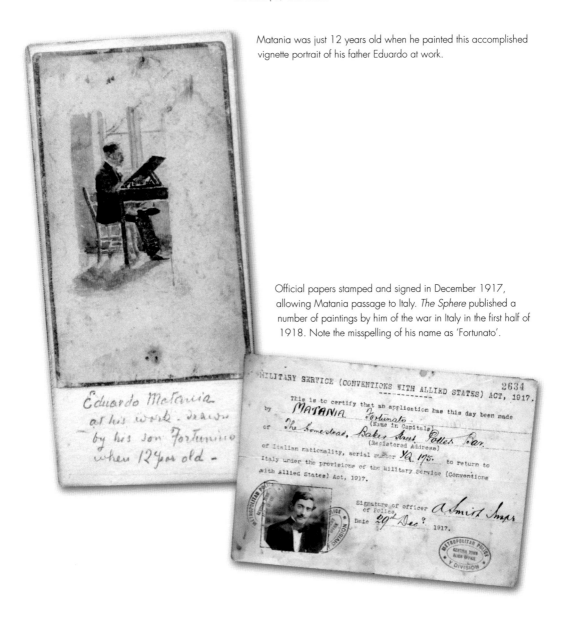

Official papers stamped and signed in December 1917, allowing Matania passage to Italy. *The Sphere* published a number of paintings by him of the war in Italy in the first half of 1918. Note the misspelling of his name as 'Fortunato'.

'My Studio.' A magnificent, autobiographical oil on canvas by Matania showing the antiquarian splendour of his studio at 104 Priory Road, Hampstead, London. Seated in the Renaissance dress is Goldie, his second wife, who regularly posed for the artist. The painting was included in 'An Exhibition of Paintings by Fortunino Matania' at Foyles Art Gallery, Charing Cross Road, in September 1950, but was indicated as not for sale.

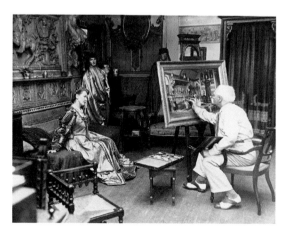

Goldie posing for 'Mr Matt' in his studio, c.1950.

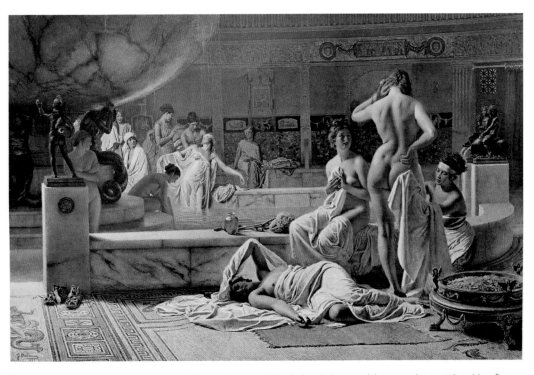

'The Bath.' Matania painted this picture in 1923, working round the clock with three models to complete it. Admirably reflecting his love of the female form, and his ability to imbue his paintings with historical atmosphere, it remained one of his favourites; he declared, 'Even if I am starving, I will not sell it.'

The Sphere brought out a London Season Number every spring and Matania illustrated the cover in 1914. It would be another six years before the London Season was back in full swing.

Boadicea, Queen of the Iceni, starred in the series of 'Famous Women from History' written by Kenneth Bell and illustrated by Matania in *Britannia* and *Eve* magazine, June 1929.

Dust jacket illustration from 1938 by Matania for *The Scarlet Beast* by Francis Gerard, showing his taste for historical exotica.

Matania illustrated a Blackpool souvenir brochure in 1938 and this stunning picture of the famous Tower Ballroom shows his confidence and flair for painting subjects on a grand scale.

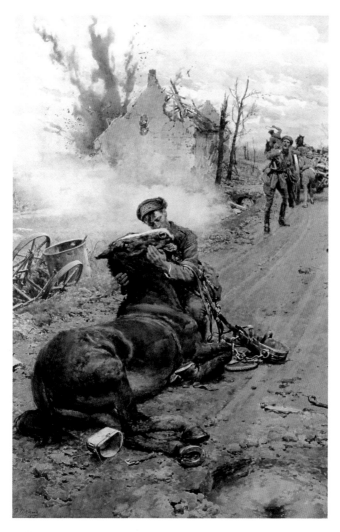

'Goodbye, Old Man – An Incident on the Road to a Battery Position in Southern Flanders.' Matania's most famous (and, for some, most moving) picture, originally painted for the Blue Cross, was published by *The Sphere* in a number of variations, including this special issue photogravure most likely dating from around 1921 when the magazine was promoting the prints for 6s each. (Photogravure, c. 1921)

A number of Matania's most popular pictures were issued as colour postcards including, naturally, 'Goodbye, Old Man'.

Postcard with a colour version of the 'White Flag Ambush of Northamptonshire Regt' (original is on p. 49).

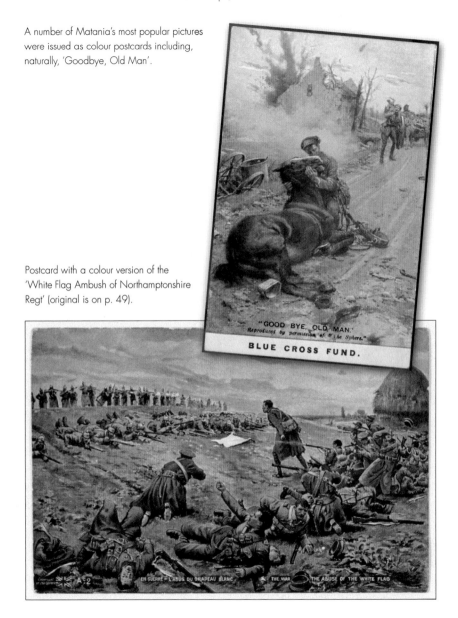

"GOOD BYE, OLD MAN."
Reproduced by permission of "The Sphere."

BLUE CROSS FUND.

EN GUERRE - L'ABUS DU DRAPEAU BLANC THE WAR THE ABUSE OF THE WHITE FLAG

'The Fall of the German Airship L-21.' The destruction of the German airship L-21 over Cuffley, Hertfordshire, after being shot down by Lieutenant William Leefe Robinson on the night of 2–3 September 1916. The glow cast out by the immense conflagration is captured by Matania, who also depicts cows running away in the field where the airship fell. (*The Sphere*, 9 September 1916)

'Convalescent – Sphere Christmas Number 1914.' The special Christmas issues produced by illustrated weekly magazines during wartime called for something more heart-warming as a welcome relief to readers. Matania's solution was to paint an officer at home by a blazing fire, his arm in a sling, regaling his female relatives with tales from the front. (*The Sphere*, 7 December 1914)

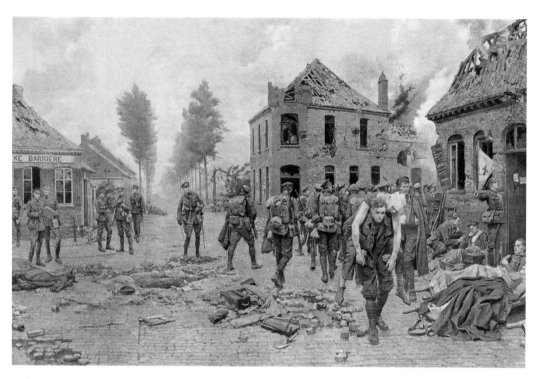

'2nd Bn., The Green Howards Holding the Petit Kruiseek Crossroads on the Ypres–Menin Road, October 1914.' Painted in 1925, Matania's scene depicts a rifle company moving up the line on the road to Kruiseeks, past the aid post where wounded men are receiving medical attention. The incident took place on the late afternoon of 22 October 1914 when there was a moment of brief respite for the men of the 2nd Battalion the Yorkshire Regiment. Central to the painting is Private Henry Tandey, who carries a wounded comrade. In a five-week period, between 25 August and 28 September 1918, Private Tandey was awarded the three highest awards for gallantry in the face of the enemy. He refused to take promotion and consequently became the most highly decorated private soldier of the war. By November 1918 he had been awarded the Victoria Cross, Distinguished Conduct Medal, Military Medal and five mentions in Despatches. In a 1932 magazine article, the writer Langston Day tells a possibly apocryphal story of how Neville Chamberlain had seen a copy of the picture at Berchtesgaden during his visit to Hitler in 1938. The Führer explained that he kept the picture as a memento because he had missed death 'by a miracle when Tandey had attacked his detachment and taken thirty-seven prisoners'.

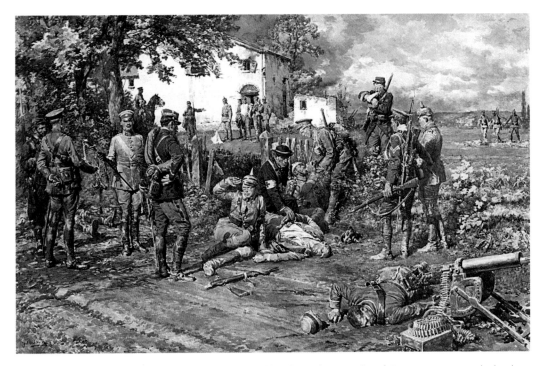

'France and Britain Together in the Field.' French and British soldiers have taken a number of Germans prisoners and a local priest acts as a Red Cross worker. The French soldier wears the navy 'kepi' jacket and bright red trousers, soon deemed too conspicuous and replaced by the more muted grey-blue (known as *bleu horizon*) in 1914. Likewise, the spiked Pickelhaube helmet worn by German soldiers, and much prized by the British as war trophies, was seen less and less as the war progressed. This illustration was also part of a retrospective of the war published by *The Sphere* in 1919 showing the character of the war in its early weeks. (*The Sphere*, 7 December 1914)

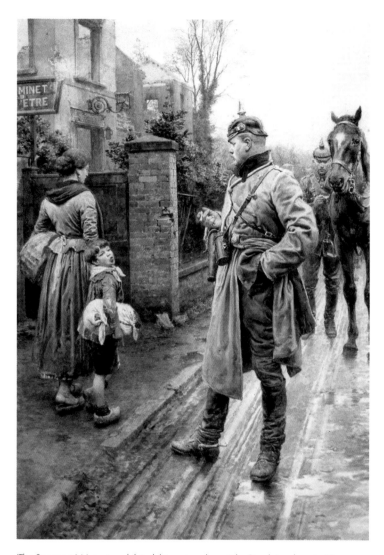

'The Strongest.' Matania exhibited this watercolour at the Royal Academy in May 1915. The art critic of *The Times* called it 'merely an illustration, but a vivid and amusing one'. (Original watercolour, 1915)

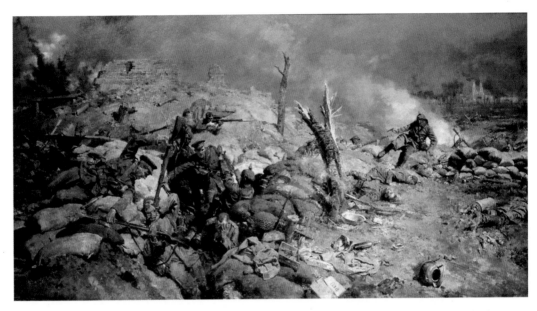

'Neuve Chapelle, 1915.' Matania went to incredible lengths to achieve this painting, visiting the battlefield despite the dangers of machine-gun fire and trenches – back at home, he dug a trench in his own garden. The result is highly dramatic and although Matania, like most artists, avoided any graphic depictions of gore, it is nevertheless a stomach-clenching image recording the desperate savagery of battle while all around is the debris of everyday life. The original oil painting is owned by the Royal Worcestershire Regiment Museum; the 1st Battalion of the regiment took a leading role in the fierce fighting during the battle. (Original oil painting, 1915, exhibited at the Royal Academy 1918. Courtesy of the Royal Worcestershire Regiment Museum)

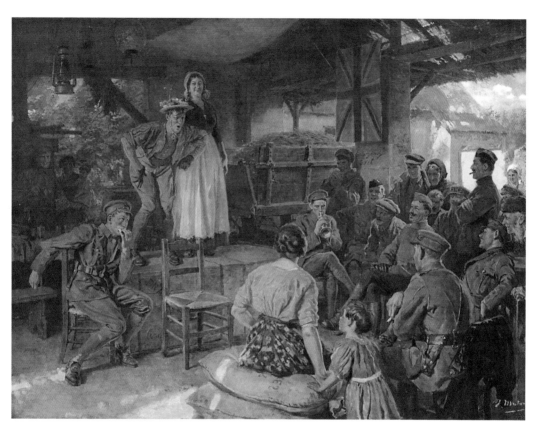

'Somewhere Behind the Lines – A Concert Behind the Lines.' A concert troupe or divisional entertainment company often made up of a mix of professional and amateur actors, putting on a show for Allied troops. One man is dressed gamely, and convincingly, in drag. Among the numerous concert troupes active during the war were the Whizzbangs, the Very Lights, the Duds, the Onions and the Gamecocks. (*The Sphere*, 29 November 1915)

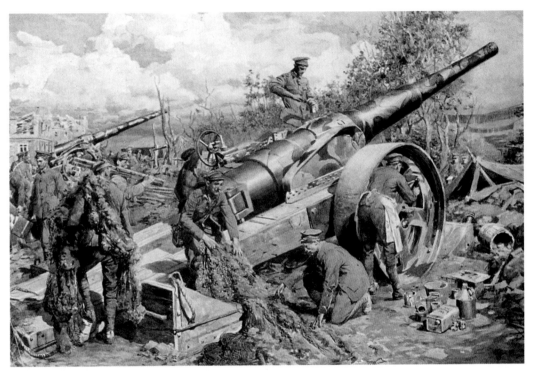

British gunners in action during the Battle of the Somme. Their guns are on 'Percy Scott' mountings, with rather colourful camouflage paint. (Reproduction, origin unknown)

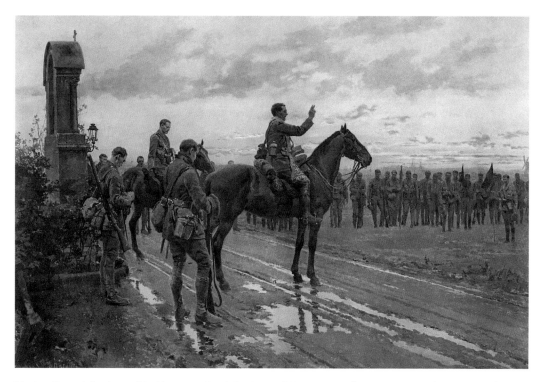

'The Last General Absolution of the Munsters at Rue-du-Bois', one of Matania's most famous paintings, relates to an incident in May 1915 when the 2nd Battalion of the Royal Munster Fusiliers suffered very heavily at Rue-du-Bois, in the Pas-de-Calais close to Arras. The action was only one of many local attacks which ended disastrously through lack of support. Colonel Victor Rickard, recently appointed to command, was killed in the attack, as was his Adjutant, Captain Filgate. Both are represented in the picture, alongside Father Gleeson, who is shown giving the Absolution on the evening prior to the action taking place. (*The Sphere*, 27 November 1916)

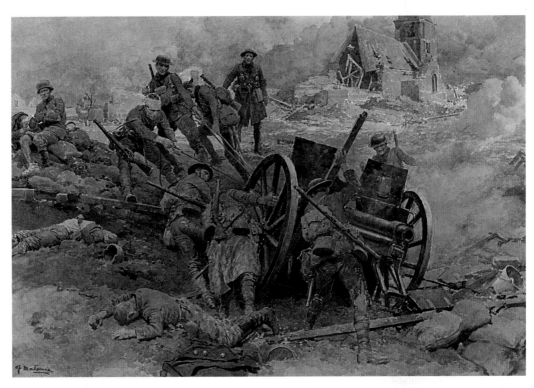

'British Advance on the Western Front.' British soldiers drag a captured German field gun into a new position in order to use it against the enemy. (*The Sphere*, 26 May 1917)

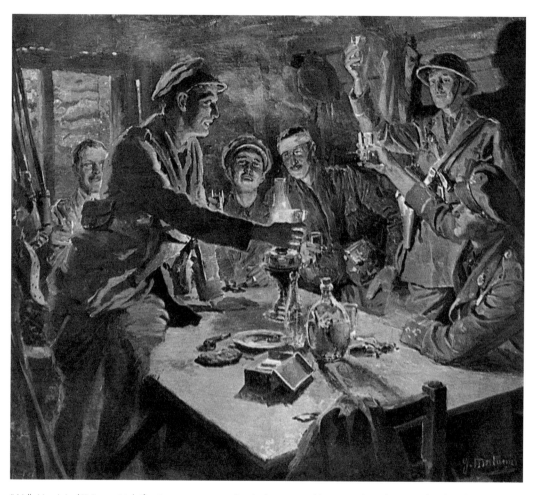

'Well, Here's Luck!' A convivial, if poignant, scene in a British dug-out as soldiers raise their glasses and wish each other luck for the coming battle. (*The Sphere*, 26 May 1917)

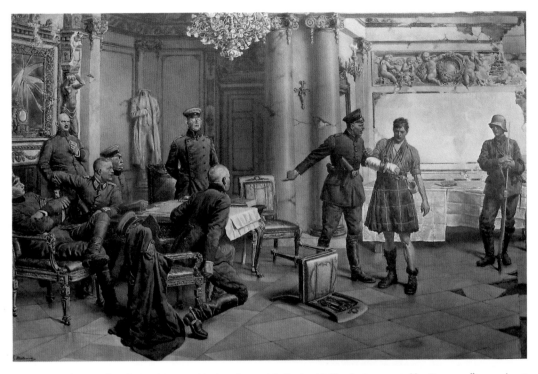

'"I won't" – After a Raid on the British Lines in Northern France.' A Gordon Highlander interrogated by German officers, who sit with a map laid out on the table in front of them. The overturned chair hints that some unchivalrous techniques may have been used. Very similar to 'I Don't Know', published in *The Sphere* in 1918, both images depict lone prisoners, vastly outnumbered but with a heroic determination to remain loyal and defiant rather than give away military positions. (Colour lithograph, date unknown)

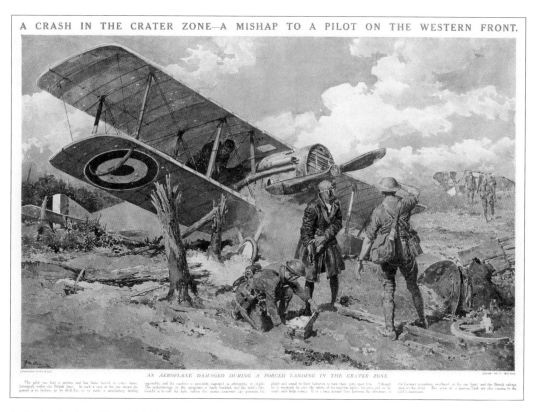

A CRASH IN THE CRATER ZONE—A MISHAP TO A PILOT ON THE WESTERN FRONT.

AN AEROPLANE DAMAGED DURING A FORCED LANDING IN THE CRATER ZONE

'A Crash in the Crater Zone – A Mishap to a Pilot on the Western Front.' A wounded pilot forced to crash-land, fortunately behind the British lines, is assisted by a salvage crew and given first aid. Assistance has also arrived in the form of the crew of a passing tank sporting multi-coloured camouflage. All face a race against time to save the aeroplane before the observers in the German aeroplanes above report the location. (*The Sphere*, 27 October 1917)

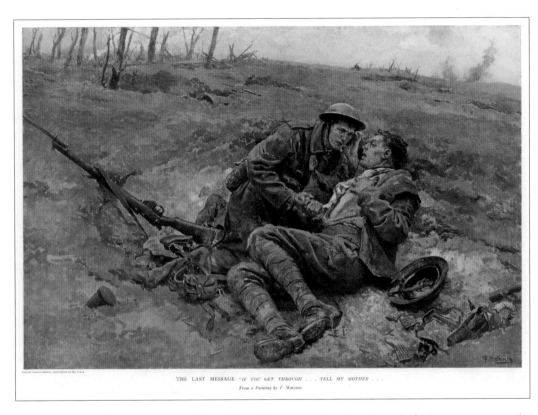

THE LAST MESSAGE—"IF YOU GET THROUGH . . . TELL MY MOTHER . . ."

From a Painting by F. Matania

'The Last Message ... If you Get Through ... Tell My Mother.' This painting of a soldier relaying his final message to a comrade as he lies dying in the mud of no-man's-land must have been particularly affecting for many whose sons had been killed on the Western Front, and demonstrates that Matania could manipulate emotions through his pictures as well as anyone. This painting was gifted to the Imperial War Museum by the artist in 1957. (*The Sphere*, 26 November 1917)

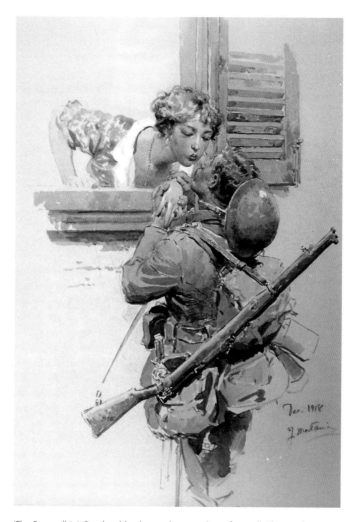

'The Farewell.' A British soldier kissing his sweetheart farewell. The window shutters are more typical of France than Britain, suggesting that this girl is probably French. Whether this is a full-blown wartime romance or a friendly, morale-boosting kiss is left to the viewer to decide. (Original watercolour, dated February 1918).

Representatives of the Allied countries climb the steps to a classical temple to be crowned with victory laurels by the goddess Nike. An allegorical illustration of the war and a foretaste of the historical and classical genres Matania would increasingly depict in the 1920s and '30s. (*The Sphere*, 1 February 1919)

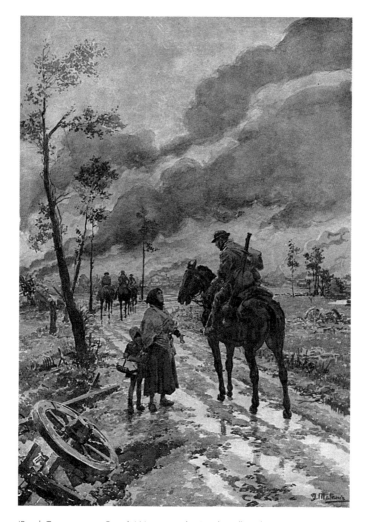

'British Trooper meets French Woman on the Road to Lille.' This poignant scene, capturing the devastation wrought upon the French landscape by the war, shows a British trooper stopping to speak to a French woman and her child. According to the caption, the woman explains that her home is gone and her husband has been killed at Verdun. (*The Sphere*, 15 March 1919)

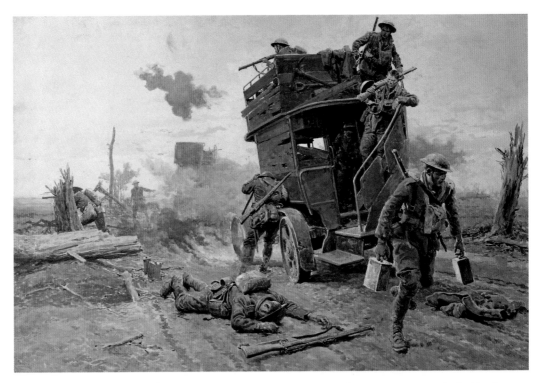

'A Sudden "Strafe" on the Road to the Trenches: A Motor 'Bus in a Hot Corner on the Western Front.' Hundreds of London omnibuses were requisitioned during the war for use at the front, where they became affectionately known as Old Bill – also the name of the soldier character created by Captain Bruce Bairnsfather in *The Bystander*. 'The old London 'buses,' wrote Philip Gibbs, 'take men to the front after a rest between the battles, and at the journey's end there will be more dirty work. But on the way they are filled with joking fellows, and grinning faces look over the top as they pass through the Flemish villages and along the line of marching troops who would like a lift like this ...' This bus has been caught in a sudden attack, hurting some of the men travelling on the top deck. (*The Sphere*, 29 September 1917)

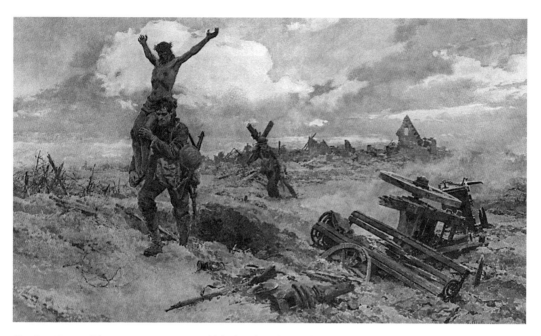

'The Cross-Bearers.' This arresting image was published in *The Sphere*'s Christmas Number on 30 November 1918 and was a reproduction of an original oil painting by the artist. It was accompanied by no further information and it is uncertain whether Matania witnessed this scene himself. Either way, the image of the soldier struggling through the devastated landscape with the carved figure of Jesus is a potent comment on redemption and resurrection after the horror of war. Wayside crosses were a common sight at junctions and crossroads around the French countryside and the name 'Crucifix Corner' was given to several locations where one was sited. At Crucifix Corner south of High Wood, near Bazentin-le-Grand, the original crucifix can still be seen today – complete with holes and scars from damage sustained.

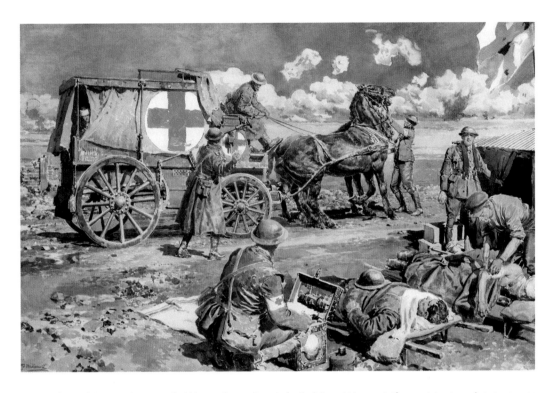

'At an Advanced Dressing Station on the Western Front – Arrival of a Red Cross Waggon.' After receiving immediate treatment out on the battlefield or at a regimental aid post situated in or near the front line, wounded men would then be transported – in this case by horse-drawn ambulance – to an advanced dressing station where they would be received into the care of the Royal Army Medical Corps. Following that, they would journey to a casualty clearing station and then to a base hospital, and perhaps then further back to hospital in Blighty. Advanced dressing stations were rudimentary, as Matania shows here, with shelter provided by shelled farm buildings, cottages, or, as here, a small hut with a corrugated roof. Those close to the front line might be in a dug-out. (*The Sphere*, 26 May 1917).

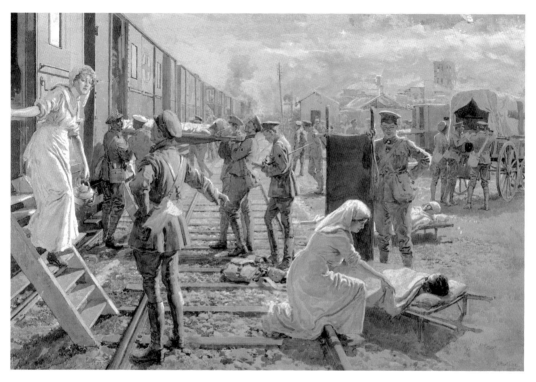

'Taking the Wounded Aboard a British Ambulance Train on the Western Front.' Nurses and Royal Army Military Corps orderlies lifting wounded soldiers to their compartments on board a British ambulance train. For a wounded man, the journey from the initial on-the-spot treatment at a regimental first-aid post in the front line back to Blighty could be long and arduous. The process of transferring the wounded from ambulances to the train was slow, as men had to be checked and loaded into compartments depending on whether they were 'sitting' or 'lying' (i.e. stretcher) cases. Matania's picture shows the procedure taking place in daylight, with most men entrained and the final few cases being dealt with. (Original monochrome artwork reproduced in *The Sphere*, 6 May 1916)

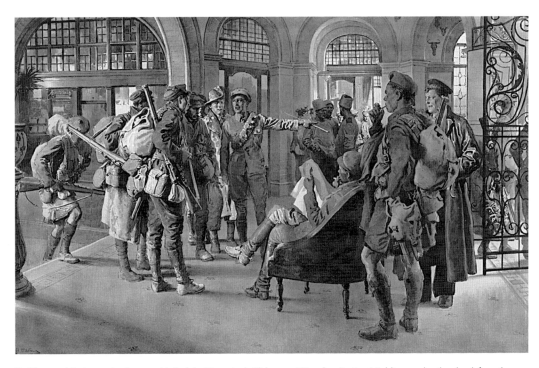

'Soldiers and Sailors in the Entrance Hall of the Union Jack Club, near Waterloo Station.' Soldiers and sailors back from the front arrive at the entrance hall of the Union Jack Club near Waterloo Station. The club was funded through public subscription and opened in 1907 by King Edward VII as a club for servicemen home from the front and offered a dining room, smoking room, library, billiard room, barber, bathrooms, bedrooms and a temporary address while in London. The club also welcomed foreign servicemen. In the background can be seen a group of Russian soldiers. In the same issue, *The Sphere* highlighted an appeal for funds in order to provide a new extension to the premises. (*The Sphere*, 13 May 1916)

Italian troops entrenched on a crest in the High Alps watch as Austrian soldiers are swept away by an avalanche due to the gradual melting of snow. Both sides – the Italian Alpini and the Austrian Kaiserschutzen – suffered losses due to avalanches during the Alpine campaign and, a century on, evidence of the so-called 'White War' continues to be revealed by the retreating ice. As recently as September 2013, the preserved bodies of two teenage Austro-Hungarian soldiers were found at the Northern Italian ski resort of Peio in Trentino province. (*The Sphere*, 27 May 1916)

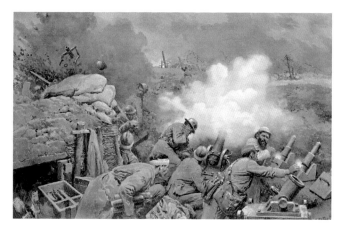

'Trench Artillery on the Western Front – A Combat in Progress.' French gunners opening fire with their special artillery for use in the trenches. To the right are a mortar and several small trench guns, while on the left, in front of the shelter, reply fire from the German trenches has scored a direct hit with equipment and a steel helmet is thrown up in the air. (*The Sphere*, 3 June 1916)

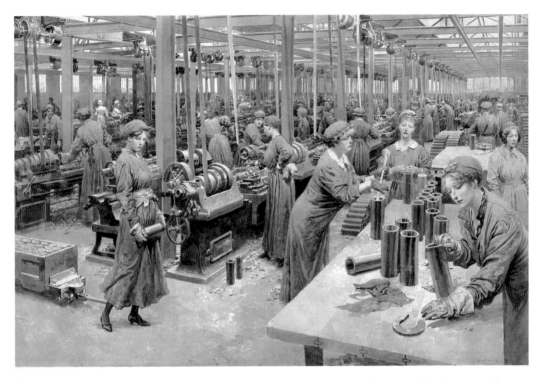

The grand scale of shell production is conveyed by this staggeringly cavernous munitions factory, with the humming machines seeming to disappear into infinity. Munitions workers earned relatively high wages but there was a price to pay: there were dangerous side-effects associated with the chemicals, and those working with TNT developed yellow faces and hands, earning them the nickname 'canaries'. Matania regularly used members of his family as models for his work; this picture features Goldie (Ellen Jane Goldsack), who became Matania's second wife in 1960. (Original monochrome artwork, reproduced in *The Sphere*, 24 June 1916)

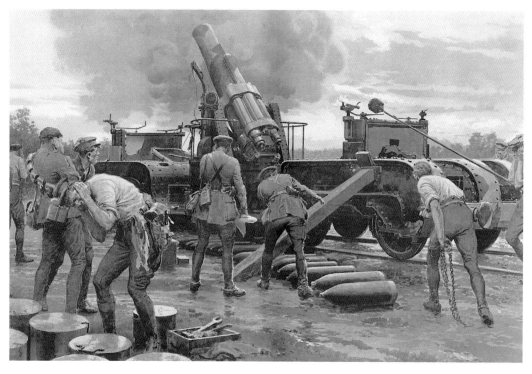

'With the British Heavy Guns on the Western Front.' A British heavy howitzer in action on the Western Front against an opposing German position. The shot has just been fired and Matania's drawing (done from official material supplied) shows the men standing clear of the heavy steel truck on which the gun is mounted. (*The Sphere*, 8 July 1916)

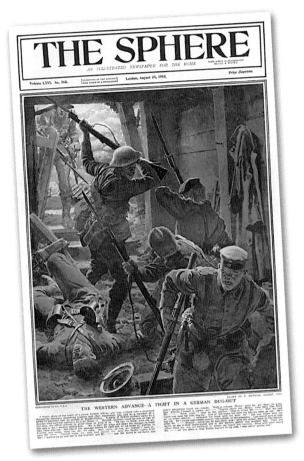

'The Western Advance – A Fight in a German Dug-Out.' This picture recounts an incident told by a member of a group of wounded men who had recently arrived at Southampton in August 1916. A party of British soldiers, approaching a German dug-out with the door blown in, were led by their officer, who insisted on going ahead. The Germans within feigned injury and asked for help, bayoneting and killing the officer when he went inside. The reaction of his men is illustrated by Matania in this front-cover image – the dying officer can be seen lying on the ground to the left of the picture while the German occupants of the dug-out run from the attack. The frequency with which examples of this kind of behaviour by the Germans are portrayed by Matania (and other artists) can be disturbing from a modern-day perspective. Undoubtedly, there were incidents where the British sense of fair play was abandoned, but in the context of the time, these stories had a subliminal propagandist message to readers at home. (*The Sphere*, 26 August 1916)

'The R.A.M.C. in No Man's Land.' Men from the RAMC bringing in the wounded. It is an image which emphasises the incredibly difficult and dangerous task faced by those who brought in the wounded. In many cases, the only safe option was to do so at night and it is significant that the two men awarded a VC and bar during the First World War – Noel Chavasse and Arthur Martin-Leake – both belonged to the RAMC. (*The Sphere*, 2 September 1916)

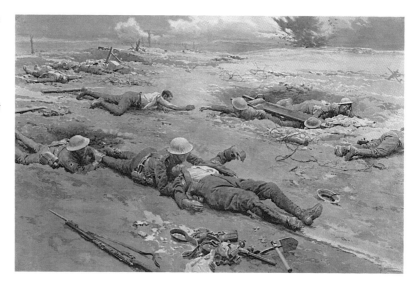

'Clearing Away Wreckage at Cuffley.' A scene at Cuffley, Hertfordshire, showing the wreckage of the L-21 German airship brought down on the night of 2 September 1916. The scene was witnessed first-hand by Matania, who lived close by, and shows firemen and men of the Royal Flying Corps sorting through the wreckage and wire. Matania describes the 'mass of grey wire in inextricable entanglement ... all that was left of the flaming titan of a few hours before'. (*The Sphere*, 9 September 1916)

'Canada's Part in the Somme Advance: A Brilliant Affair at Courcelette.' The Battle of Flers-Courcelette, part of the Somme offensive, was launched on 15 September 1916, the date depicted by Matania in this illustration. The battle marked the debut of the Canadian divisions and is also notable for the first use of the tank (called 'armoured cars' in *The Sphere*) in warfare. Matania shows the capture of the sugar refinery at Courcelette. The Canadians finally captured the whole village, took over 1,200 prisoners including thirty-two officers, two guns and a large number of machine guns and several heavy trench mortars in the course of heavy fighting. (*The Sphere*, 11 November 1916)

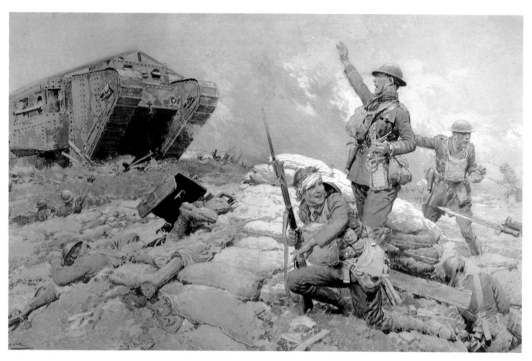

'Auckland's Advance from its Battalion Headquarters.' An illustration relating to an incident on the 14/15 September 1916 described in *A Saga of the Sword* by Austin F. Britten (published by Arrowsmith, London, 1928). The picture shows members of the 2nd Battalion Auckland Regiment, which was in no-man's-land, 50yd or so from the German front line in Coffee Lane, advancing with the back-up of tanks from its battalion headquarters, slightly on the right of 'La Forche', where the New Zealand memorial now stands. Four tanks from D Company, numbered D8, D10, D11 and D12, were allocated to the New Zealand Division and all four passed over this area towards La Forche before spreading out. The actual image was never used in the book (which in the end did not have any illustrations). (Original monochrome artwork)

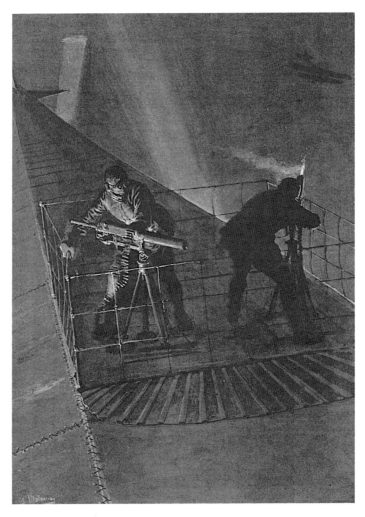

Zeppelin machine gunners attempting to beat off a British aeroplane attack. The gunners are positioned, somewhat precariously, on a 9ft platform above the bow end of the airship, which pitched and rolled with the swaying airship and frequently nose-dived in order to avoid searchlights and shells. A light wire fencing was all that prevented the men rolling off the roof of the airship. This view of the platform was reconstructed by Matania after an examination of a fallen Zeppelin, most probably the L-21 airship. (*The Sphere*, 9 December 1916)

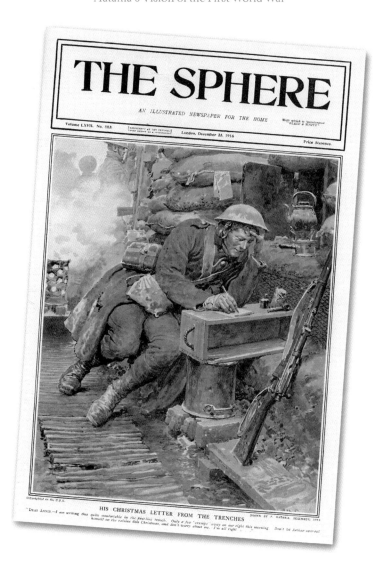

'His Christmas Letter Home from the Trenches.' This British soldier, surrounded by sandbags in his trench, writes a letter home to his family at Christmas using an ammunition box as a makeshift desk. A brazier provides warmth. (*The Sphere*, 23 December 1916)

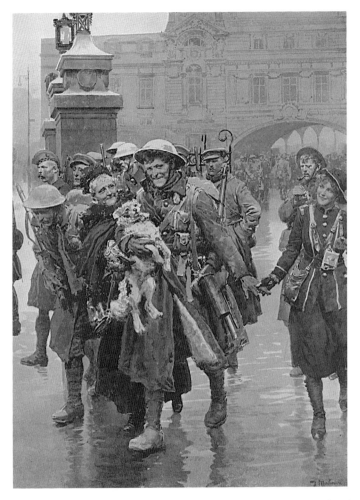

'Christmas Leave, 1916 – Victoria Station.' A heart-warming scene showing soldiers home on leave for Christmas exiting Victoria train station. The central figure, still in tin helmet and trench coat, is reunited with his mother, his pet dog and his sister who, in common with many women around Britain, is taking on a traditionally male role – in this case she is wearing the uniform of a London tram conductor. Matania had his favourite models and the elderly lady who models for the soldier's mother in this picture is recognisable as the French lady evacuated by a gallant British motorcyclist on p. 118. (*The Sphere*, 30 December 1916)

'Christmas Festivities in the Shakespeare Hut.' A busy scene of festive jollity at the Shakespeare Hut, one of numerous YMCA huts erected around London during the war to provide rest, food, temporary accommodation and recreation for soldiers passing through the capital. The Christmas party was organised by Lady Forbes-Robertson and Mrs Matthias, who ensured each and every one present received a gift. (*The Sphere*, 6 January 1917)

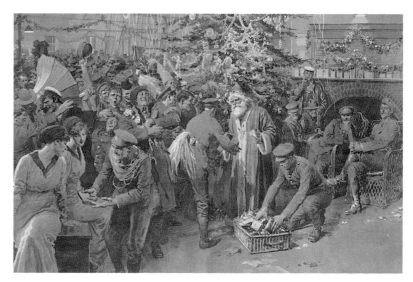

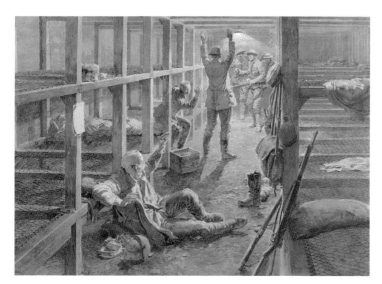

'The Piercing of the German Fortified Line: A Dug-out with Sleeping Accommodation for 800 Men.' German soldiers are given a rude awakening when their dug-out is taken by the British. German dug-outs had the reputation of being expertly constructed and often quite comfortable – though a disadvantage when surprised by an attack such as this. In a report by Philip Gibbs, related in *The Sphere*, he writes how 'these sleeping men awoke and knew that they were trapped like rats in their holes'. (Original monochrome artwork reproduced in *The Sphere*, 31 March 1917)

'His Other Eyes.' A blind soldier sits and listens as a female companion reads from a newspaper or magazine, keeping him updated with news. This drawing was donated by the artist to a sale held at the Albert Hall in May 1917 to raise money for St Dunstan's, a hostel in Regent's Park, London, set up by Sir Arthur Pearson to care for blinded servicemen. (*The Sphere*, 19 May 1917)

Opposite: A wounded French soldier lying in bed in a hospital ward is entertained by an elegant visitor. The hospital's former purpose as a school is evidenced by the charts and posters hanging on the wall. (Original monochrome artwork, *c.* 1917)

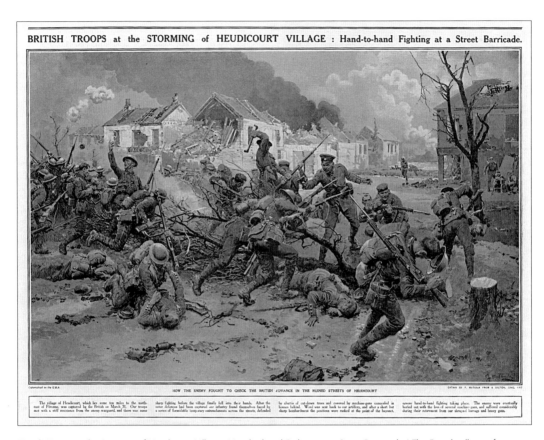

'British Troops at the Storming of Heudicourt Village: Hand-to-hand Fighting at a Street Barricade.' The French village of Heudicourt was one of a number that fell in and out of Allied possession during the see-saw of advances and retreats on the Western Front. German entrenchments stretched across the street and Matania's picture shows a scene of fierce, hand-to-hand fighting in March 1917 following an artillery barrage, resulting in a British capture of the village. It remained in British hands until the German advance of March 1918 and was retaken in September 1918. (*The Sphere*, 16 June 1917)

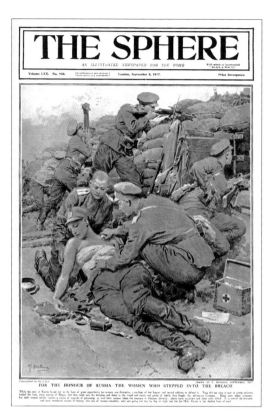

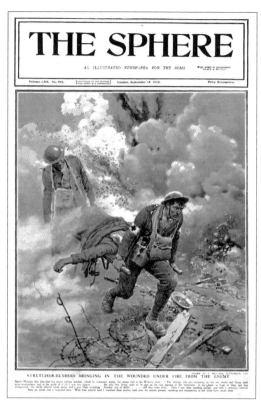

'For the Honour of Russia – The Women who Stepped into the Breach.' Matania's picture of Russia's famous female Battalion of Death is perhaps a somewhat romantic depiction. It's possible he chose to depict the wounded soldier as bare-breasted in order to make clear her gender in what is an otherwise wholly masculine scenario. (*The Sphere*, 8 September 1917)

'Stretcher-bearers Bringing in the Wounded Under Fire from the Enemy.' This dramatic scene was accompanied by the following narrative: 'The barrage fire was screaming in the air, smoke and flying earth were everywhere, and in the midst of it all I saw two figures … the only two living souls to be seen on the vast expanse of the battlefield. A shell burst in front of them and they disappeared; the smoke cleared away again and I saw them crouching. Another rain of shells … still they were alive. Then I saw them standing upright, and with a stretcher between them on which was a wounded man. With their painful load I watched them … vanishing and reappearing as the shells burst round them.' (*The Sphere*, 15 September 1917)

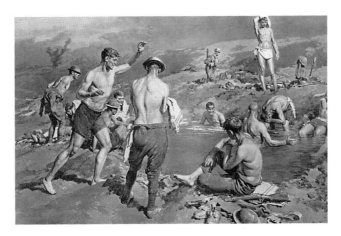

'British Soldiers Bathing in flooded Shell Hole.' According to *The Sphere*, the only advantage of the wet weather on the Western Front was a novel swimming bath used by British soldiers for bathing. The scene was captured from life by Matania, who visited the front in 1917, and gave him a chance to exhibit his knowledge of human anatomy. (*The Sphere*, 15 September 1917)

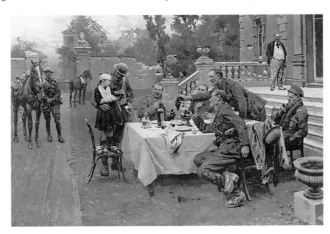

'The Only Wounded in the Village.' A small French girl, wounded by a splinter from a shell flung at her village by an enemy gun miles away on the other side of the firing line, is presented to a group of British officers having their evening meal at a small chateau. Matania was no doubt familiar with 'And When Did You Last See Your Father?' by Frederick Yeames; the composition and subject are similar, though, in this case, the little girl is not facing interrogation but the kindliness of the British officers. (*The Sphere*, 20 October 1917)

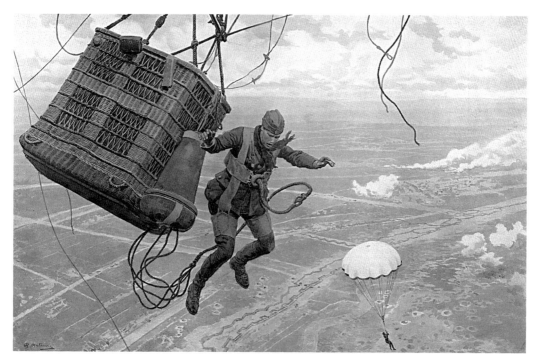

'A Leap for Life – Dropping from the Car of a Kite Balloon.' A British observer drops from the car of a kite balloon, attached to a parachute (known as an 'acorn') hanging over the side of the basket. His colleague has already jumped and is on his way to the ground. Observation balloons were tethered to the ground, but if a sudden squall were to blow up there was the risk of the cable snapping and the balloon drifting over enemy-held territory. In such circumstances, charts and instruments would be thrown out and then each observer in turn would make what was known as 'the drop out'. Hopefully they would land safely, and not behind enemy lines. (*The Sphere*, 27 October 1917)

'An Interlude.' Amid the ruins of a French chateau, a French soldier stands and sings to accompaniment on a grand piano by a British officer. Around the pair, more British officers sit in quiet contemplation, perhaps remembering similar scenarios in more civilised times. Matania's ability to create atmosphere was consummate, and the presence of music amid such blatant destruction here conjures up a particularly emotive image. (*The Sphere*, 3 November 1917)

'Artillery Advancing through the Swamps of Flanders: Gunners Dragging their Gun through the Mud.' The mud of the Western Front brilliantly realised by Matania in this impression of British gunners and their horses dragging their gun through a near-swamp on their way to take up a forward position. (*The Sphere*, 1 December 1917)

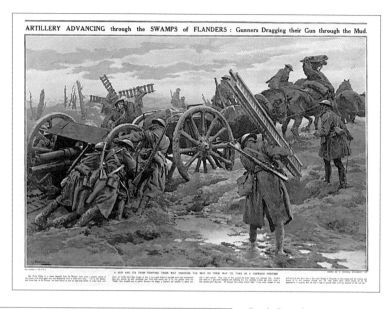

ARTILLERY ADVANCING through the SWAMPS of FLANDERS : Gunners Dragging their Gun through the Mud.

A GUN AND ITS TEAM FIGHTING THEIR WAY THROUGH THE MUD ON THEIR WAY TO TAKE UP A FORWARD POSITION

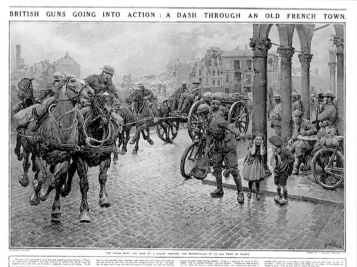

BRITISH GUNS GOING INTO ACTION : A DASH THROUGH AN OLD FRENCH TOWN.

THE TEAMS BRING THE GUNS AT A GALLOP THROUGH THE MARKET-PLACE OF AN OLD TOWN IN FRANCE

'British Guns Going into Action: A Dash Through an Old French Town.' A British artillery piece is rushed at a gallop through the marketplace of a French town, the square of which is surrounded by shell-damaged buildings. A watchful soldier ensures the two young children to the right do not venture out into the path of the horses as they gallop over the wet cobbles. (*The Sphere*, 29 December 1917)

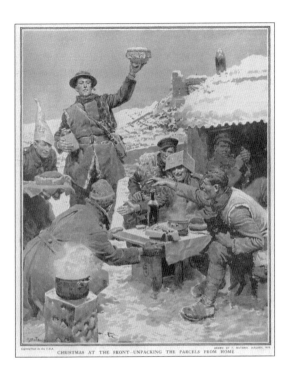

'Christmas at the Front – Unpacking the Parcels from Home.' *The Sphere* describes how 'the arrival of post is always an event which is eagerly awaited by the men at the Front, particularly at Christmas time', and this hamper, containing a plum pudding among other treats, has certainly lent a festive air to proceedings. (*The Sphere*, 5 January 1918)

'Intercession Day, January 6th 1918 – The Scene in St. Paul's Cathedral.' Arthur Winnington-Ingram, Bishop of London, preaching from the pulpit in St Paul's Cathedral to a congregation of khaki on Intercession Day. A fervent supporter of Britain's role in the war, calling it 'a great crusade to defend the weak against the strong', he acted as chaplain to the London Rifle Brigade and was unwavering and tireless in encouraging men to enlist, including younger clergy in his diocese. (*The Sphere*, 12 January 1918)

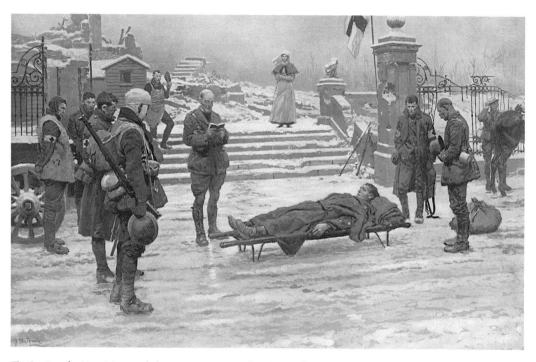

'The Passing of a Hero.' A particularly moving composition by Matania showing an army padre reading a brief funeral service in the snow for a dead British soldier, who lies, covered by a greatcoat, on a stretcher in the centre of the picture while his comrades and a Red Cross nurse stand to pay their respects. For an artist so often used to filling his pictures with numerous figures and details, here Matania employs a subdued and economical use of space conveying a bleak chill and muted solemnity in keeping with its subject. (*The Sphere*, 23 February 1918)

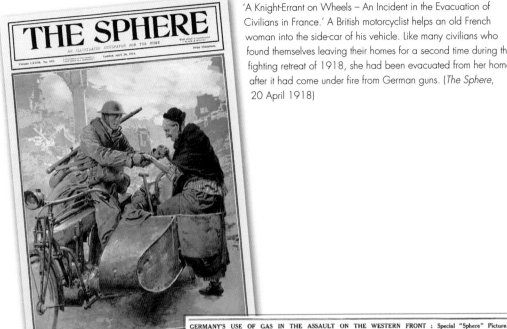

'A Knight-Errant on Wheels – An Incident in the Evacuation of
Civilians in France.' A British motorcyclist helps an old French
woman into the side-car of his vehicle. Like many civilians who
found themselves leaving their homes for a second time during the
fighting retreat of 1918, she had been evacuated from her home
after it had come under fire from German guns. (*The Sphere*,
20 April 1918)

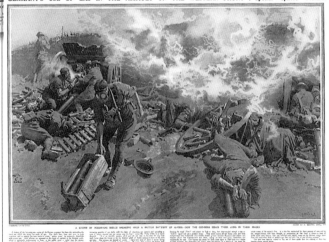

'Germany's Use of Gas in the Assault
on the Western Front.' A storm of
poison gas shells, brilliantly realised by
Matania, break over a British battery
of 18-pounders, showing the gunners
working through regardless, serving their
guns while impeded by gas masks. (*The
Sphere*, 20 April 1918)

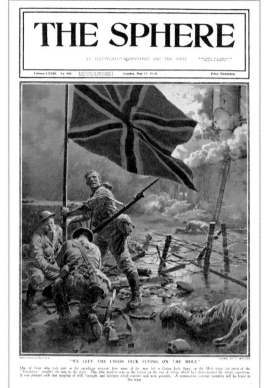

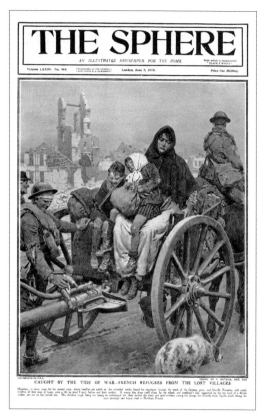

'We Left the Union Jack Flying on the Mole.' Men from HMS *Vindictive* during the Zeebrugge Raid pictured fixing the Union flag on the mole before returning to their ship. The Zeebrugge Raid failed in its objective of sinking old British warships to block German U-boats in harbour, with the loss of more than 200 men. However, the Allies reported on the episode optimistically and this front cover illustration by Matania seeks to find the positive patriotism in what was something of a disaster.

'Caught by the Tide of War – French Refugees from the Lost Villages.' A refugee French woman and her children are given a lift by British soldiers on a road in Northern France as they escape the approaching German guns during the Spring Offensive. A lovely detail is the Tommy on the left who is amusing the children by giving their doll a ride on the limber. (*The Sphere*, 8 June 1918)

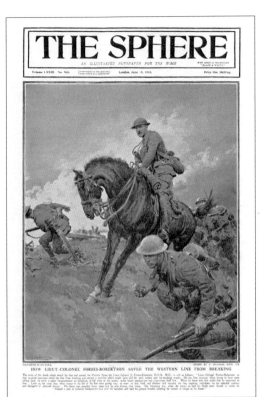

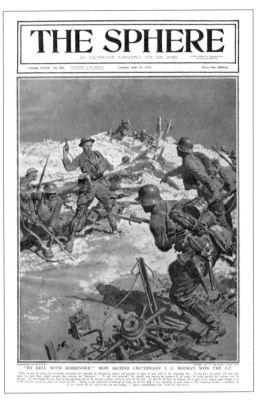

Colonel-Lieutenant James Forbes-Robertson, VC, of the 1st Battalion, Border Regiment was awarded the Victoria Cross for his actions on 11/12 April 1918 at Vieux-Beuqin, where he repeatedly saved the British line from breaking. This *Sphere* cover shows the moment Forbes-Robertson made a reconnaissance on horseback in the face of serious enemy fire. Matania's handling of equine subjects was always particularly skilful. (*The Sphere*, 15 June 1918)

Second-Lieutenant John Buchan, VC, from Alloa in Clackmannanshire was an officer in the Argyll and Sutherland Highlanders, whose actions in March 1918 in Marteville, France led to him being awarded the Victoria Cross. Despite being wounded several times, Buchan refused to leave his men and, when his platoon was surrounded, refused to surrender, shooting several Germans with his pistol. Matania's original picture capturing this moment was mounted in a carved memorial and gifted to the Alloa Public Library by the town council. (*The Sphere*, 22 June 1918)

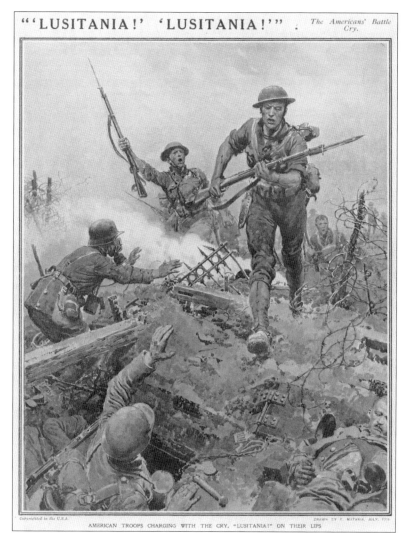

‘American Troops Charging a German Position on the Western Front.’ The Americans had to wait a long time to avenge the sinking of the *Lusitania* and this image, subtitled ‘"Lusitania!" "Lusitania!" The Americans' Battle Cry' sums up the spirit and resolve of the US soldiers. (*The Sphere*, 7 July 1918)

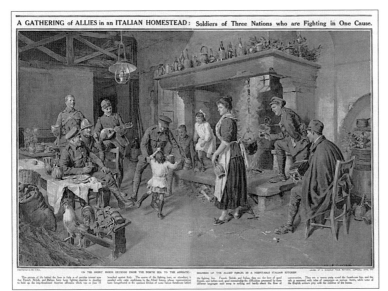

'A Gathering of Allies in an Italian Homestead: Soldiers of Three Nations who are Fighting in One Cause.' French, British and Italian soldiers gathered together in an Italian home, a subject familiar to Matania and undoubtedly a pleasure to paint. The Allies had been fighting together to hold up a long-threatened Austrian offensive which was launched against Italy on 15 June 1918. (*The Sphere*, 29 June 1918)

'I Don't Know – After a Raid on the British Lines in Northern France.' A captured soldier from a Highland regiment is interrogated by a group of fierce-looking German officers in a chateau converted into headquarters. The picture's title, and the wounded soldier's expression, strongly imply he will not be divulging any secrets to the enemy. (*The Sphere*, 13 July 1918)

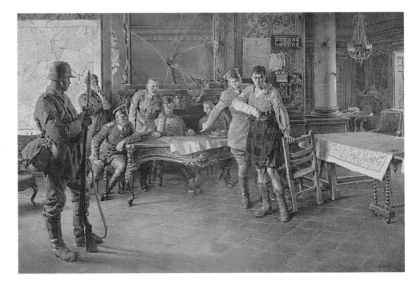

'The Fatal Marne – the Germans' Second Crossing of the River.' The Second Battle of the Marne, lasting from 15 July to 6 August, was the last major offensive by the Germans on the Western Front, but they were to come up against a resolute fighting force composed of French, British, Americans and Italians. Here, German soldiers retreat back across a bridge spanning the River Marne and suffer greatly under artillery and machine-gun fire. The failure of Germany's offensive marked the beginning of the end of the conflict, with cessation of hostilities just over three months later. (*The Sphere*, 27 July 1918)

'German Prisoners Captured by Americans, Passing Some Wounded U.S. Soldiers.' German POWs trudge in line past a damaged windmill and regard the sight of wounded Americans, one lying by the roadside on a stretcher, another applying a first-aid dressing to his hand. (*The Sphere*, 3 August 1918)

'A British Aeroplane Caught by Machine-Gun Fire while over the Enemy Lines.' A British aeroplane, caught making a daring raid over enemy lines and flying very low to drop bombs on entrenched German troops, is fired on by a machine gun as well as several rifles. According to the caption, the pilot had great difficulty in making his escape 'from the danger into which his audacity had led him'. (*The Sphere*, 10 August 1918)

'British Gunners Turning a Captured German Gun on the Fleeing Enemy.' A British artillery team with a captured gun (a 77mm) using all their strength to turn it around to fire on the retreating Germans. Artillery was hot work, especially in a French summer, and gunners often worked without their shirts on. (*The Sphere*, 17 August 1918)

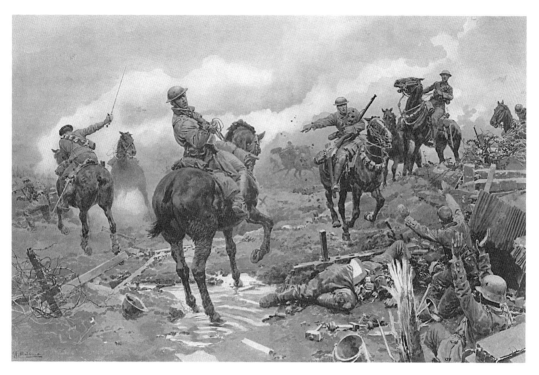

'A Cavalry Charge that Saved the Line – The German Line Taken in Flank by a Mounted Charge in the Teeth of Heavy Machine Gun Fire.' Major Evelyn H.W. Williams of the 10th Hussars was awarded the Distinguished Service Order for leading a mounted charge in the face of the heaviest machine-gun fire at Collezy in March 1918. His action rallied the infantry who advanced and recovered over 3,000yd of territory. (*The Sphere*, 7 September 1918)

'Honouring Brave Men at the King's Investiture in Hyde Park.' On 2 June 1917, in a public ceremony in London's Hyde Park, King George V invested some 350 men with the honours they had won for gallantry and good service during the war. The soldier on crutches, shown by Matania receiving his VC, is Private Thomas Hughes of the Connaught Rangers, who, though wounded, seized a hostile machine gun single-handed during the Battle of Guillemont (part of the larger Somme offensive) on 3 September 1916, and brought back several prisoners. (Original monochrome artwork, reproduced in *The Sphere*, 9 June 1917)

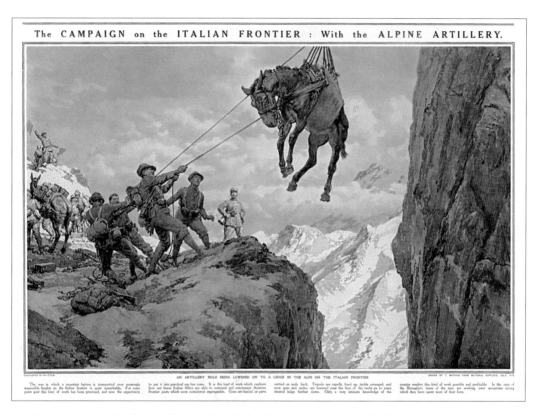

The CAMPAIGN on the ITALIAN FRONTIER : With the ALPINE ARTILLERY.

AN ARTILLERY MULE BEING LOWERED ON TO A LEDGE IN THE ALPS ON THE ITALIAN FRONTIER

'The Campaign on the Italian frontier: With the Alpine Artillery.' An artillery mule, used to haul or carry gun parts, is lowered on to a ledge in the Alps by Italian Bersaglieri soldiers, as they transport their battery over seemingly impossible heights. Italy had entered the war on the side of the Allies in the spring of 1915, declaring war on their old enemy Austria-Hungary on 23 May. (*The Sphere,* 7 August 1915)

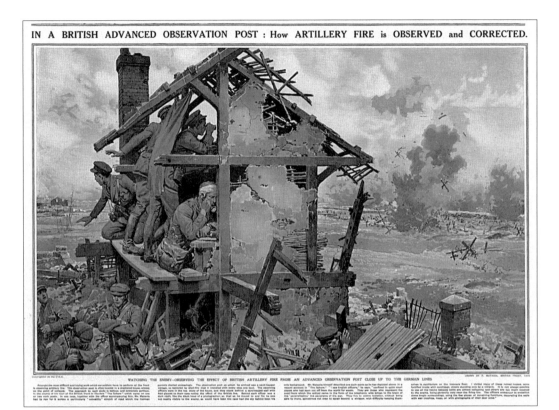

IN A BRITISH ADVANCED OBSERVATION POST : How ARTILLERY FIRE is OBSERVED and CORRECTED.

'In a British Advanced Observation Post: How Artillery Fire is Observed and Corrected.' Situated close to German lines, British officers camped in a ruined house relay information back about the accuracy of artillery fire. The dark cloth seen behind one of the officers (with binoculars) helps to disguise any movement. Seen against a background of sky, he would inevitably attract the attention of snipers. Matania himself viewed several such posts, describing the scene in *The Sphere*: 'I saw English officers, confined in quite small places who had been cut off from the world for weeks. They live in entire isolation, without being able to move, sometimes not even to speak beyond a whisper, with difficulty keeping themselves in equilibrium on the insecure floor. It is not always possible to use all the rooms because some are almost collapsing and others are too much exposed to the enemy. The officers endeavour to embellish these tragic surroundings, using the few pieces of remaining furniture, decorating the walls with war trophies, maps, or with photographs of their dear ones.' (*The Sphere*, 21 August 1915)

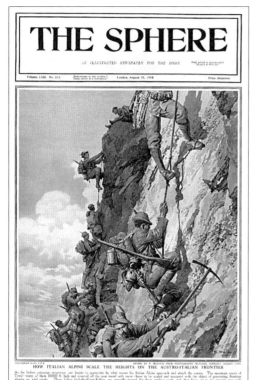

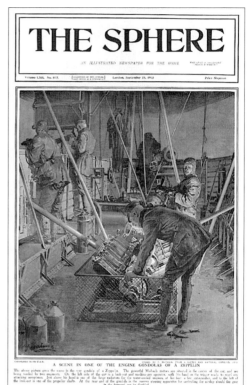

'How Italian Alpini Scale the Heights on the Austro-Italian Frontier.' Matania pictures the elite mountain troops on the cover of *The Sphere*, 21 August 1915, three months after Italy had entered the war. Most of the 600km Italian front line ran through the highest peaks of the Alps, covered year round in snow and ice. Climbing and skiing became essential skills, as the Italians and Austrians both attempted to occupy the vital higher ground which would bestow such advantage on the holder of the position. (*The Sphere*, 21 August 1915)

'A Scene in One of the Engine Gondolas of a Zeppelin.' The front cover of *The Sphere* on 18 September 1915 featured this illustration by Matania of the rear gondola of a German Zeppelin airship. In the centre, two engineers tend the powerful Maibach motors. To the left is a look-out and machine-gun operator, ready to repel any attacking aircraft. Above the gunner's head is one of the large radiators for the water-cooled engines and at his feet a fire extinguisher. To the left of the look-out is one of the propeller shafts. To the rear of the gondola can be seen the reserve steering apparatus, there in case the steering gear in the forward gondola is disabled. (*The Sphere*, 18 September 1915)

'With the R.F.C.—After Reconnaissance Work on the Western Front.' The pilot and observer of a Royal Flying Corps aeroplane are helped back to their rest quarters after returning from a reconnaissance mission. *The Sphere* of 22 April 1916 reports that 'reaction to the rapid changes in elevation sets in on landing; the effect of rarefied atmosphere, however, passes off rapidly after a good sleep'. Note the plane's camera held in the hand of one of the soldiers. (*The Sphere*, 22 April 1916)

'The Western Front in the Grip of Snow and Ice' – behind the front line, British soldiers keep warm by indulging in a snowball fight during a wintry spell of weather. (*The Sphere*, 3 February 1917)

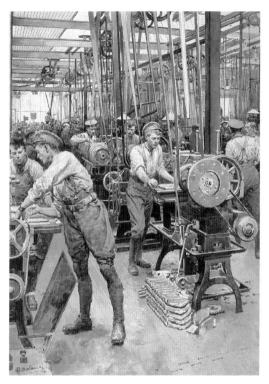

'The Returned Soldier as Munition Worker' – many men, such as those shown in their khaki uniforms in this picture, who had enlisted early in the war but were then sent back from the front found work in munitions factories. It is likely these men were recovering from light wounds and were still able to help towards the war effort. (Original monochrome artwork, reproduced in *The Sphere*, 11 September 1915)

'Keeping Off a Night Attack on the Western Front – A Ruse de Guerre in the Trenches – Firing Star Pistols and Rifles at Once.' Matunia's subtle illumination of this scene highlights a small group of soldiers left in a trench after the withdrawal of the majority of their company, attempting to impersonate a much larger body of men by firing rifles and star pistols in unison. (*The Sphere*, 25 December 1915)

'The Empty Trenches – "Come on, you fellers, there's nobody here".' Following a German retreat, an unoccupied trench falls into British hands; the British troops are seen here at the entrance to one of the deep dug-outs. On the whole, German trenches were of a more elaborate construction than those to which these British soldiers would have been accustomed. (*The Sphere*, 31 March 1917)

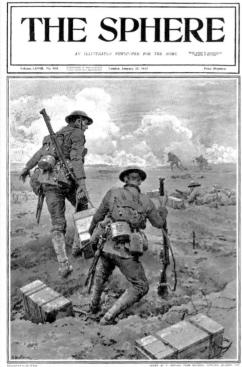

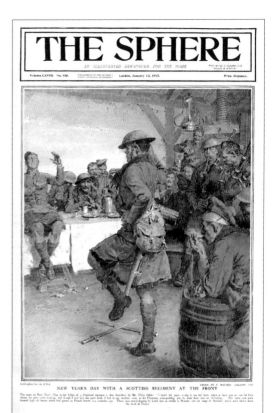

'Following the Troops Over the Edge – Plucky Work of the Ammunition Carriers.' During an offensive, keeping new trenches supplied with ammunition was vital if the advance made was to be consolidated. Here, two British soldiers carry a box of ammunition forwards, moving from shell-hole to shell-hole as opportunity allows. (*The Sphere*, 27 January 1917)

'New Year's Day with a Scottish Regiment at the Front.' In an old barn not far behind the front line – the billet of a Scottish regiment – the New Year is celebrated in traditional style, with bagpipes, sword dancing and traditional Scottish songs. (*The Sphere*, 13 January 1917)

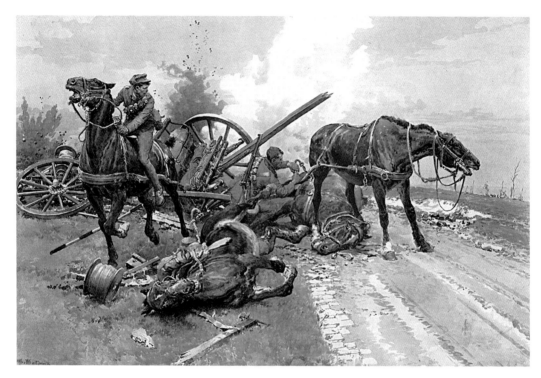

'Telegraph Work in Gallipoli: An Unrecorded Incident of Individual Bravery.' Under heavy Turkish shell-fire, two men of the 1st Royal Munster Fusiliers bring two uninjured horses back to British lines. Their four-horse wagon, carrying telegraph poles, had been badly damaged by shell explosion and two horses were killed. Freeing the surviving horses, the men rode them bareback to safety and were duly promoted. (*The Sphere*, 12 February 1916)

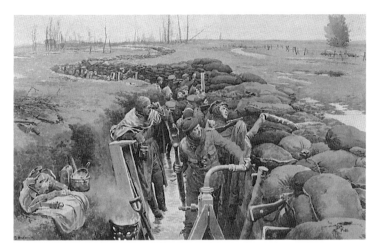

'Winter 1915 – The period of Icy-cold Water in the Trenches which Produced "Trench Foot".' Matania's picture of a flooded British trench during the winter of 1915 shows only too clearly the conditions endured. An influx of socks and instructions on how to properly care for and keep feet dry helped to control trench foot in subsequent winters. (*The Sphere*, 1 January 1916)

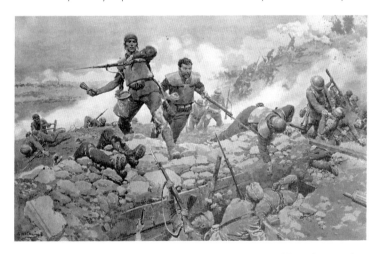

'With the Italians on the Isonzo Front: The Hastati of old Rome Reincarnated.' Italian soldiers charge and capture an Austro-Hungarian position on the Isonzo Front. They are wearing specially designed breastplate and shoulder pieces, which are reminiscent of the armour worn by ancient Roman infantry (the *Hastati*). (*The Sphere*, 9 June 1917)

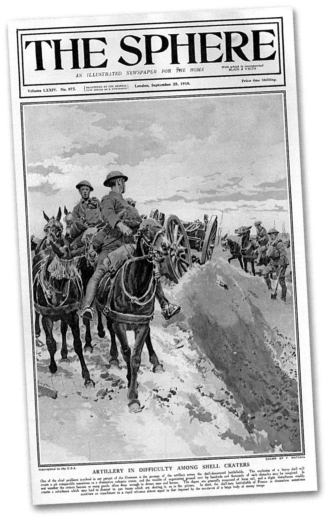

'British Artillery in Difficulty Among Shell Craters.' The pock-marked, sodden terrain of the Western Front could prove treacherously difficult for artillery pursuing the Germans across the battlefields. Shell craters created by explosions could easily subside and filled with water in wet weather. Tragically, it was not uncommon for horses, and sometimes men, to sink and drown in the mud. (*The Sphere*, 28 September 1918)

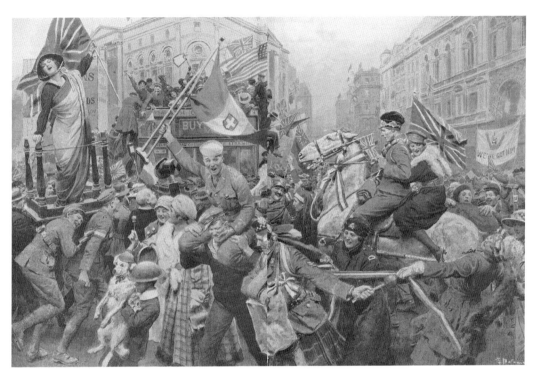

Matania's impression of victory celebrations – 'the day' that everyone had waited four long years for – is set in Piccadilly Circus and appeared in *The Sphere* on 23 November 1918, less than two weeks after the armistice – testament to Matania's continuing ability to produce tremendously detailed pictures at great speed. A joyous composition, it is an apt conclusion to the huge body of work Matania produced for *The Sphere* during the war years. (*The Sphere*, 23 November 1918)

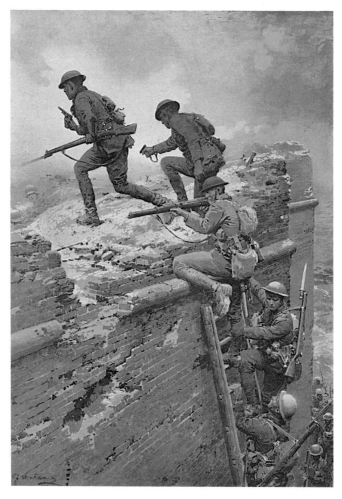

'With the New Zealand Division in the Great War.' New Zealand troops scale the walls of the French old fortress town of Le Quesnoy in their last major action of the war. The town had been occupied by German forces since August 1914 and the medieval-style assault by the 4th Battalion of the 3rd New Zealand (Rifle) Brigade, which scaled the walls and ramparts, became one of the most symbolic achievements of the ANZACs. The Germans occupying the town quickly surrendered and the townspeople have maintained links with their New Zealand liberators to this day. Matania's picture conveys the heroic daring and drama of the advance. (*The Sphere*, 18 January 1919)

'Peace Conference in Paris.' British Prime Minister David Lloyd George addressing the delegates at the Peace Conference in the Salon de L'Horloge at the Quai d'Orsay. The conference opened on 18 January 1919 and continued through that year, ending with the inaugural assembly of the League of Nations. For Britons, the signing of the Treaty of Versailles on 28 June was to bring matters to a conclusion and trigger official peace celebrations. (*The Sphere*, 8 February 1919)

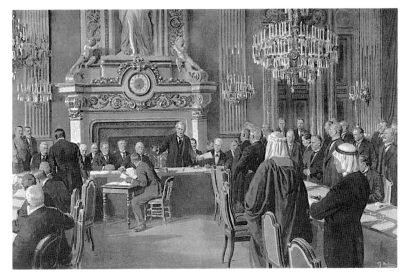

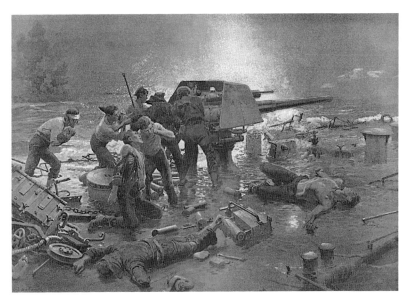

'The Last Shot.' A group of British seamen gunners straining to fire a final shot at a German ship as their own sinks beneath them, in a picture that shows off Matania's mastery of light and shade. The caption notes that this was a common occurrence with light cruisers and destroyers, as their light build rendered them liable to destruction by a single shell of moderate dimensions. Eight destroyers were lost at the Battle of Jutland, for instance. (*The Sphere*, 15 February 1919)

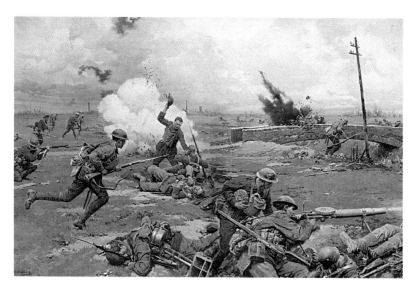

'Australian Troops Counter-Attack at Amiens.' Australian troops hold the line at Villers-Bretonneux, 9 miles east of Amiens, during a German attack in April 1918. As always, the image was an accurate impression, having been reconstructed with the help of eyewitness accounts and official material, though the intense savagery of this picture is unsettling. (*The Sphere*, 26 April 1919)

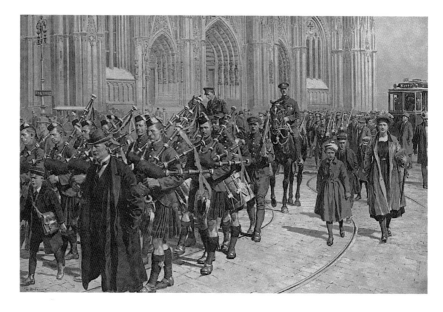

'Scots Guards Marching Through Cologne.' The pipers of the Scots Guards, resplendent in their kilts, playing troops through the streets of Cologne during the occupation of the Rhineland, in an image that recalls Matania's imagining of the British Tommies marching through Bruges in the early weeks of the war in 1914. (*The Sphere*, 24 May 1919)

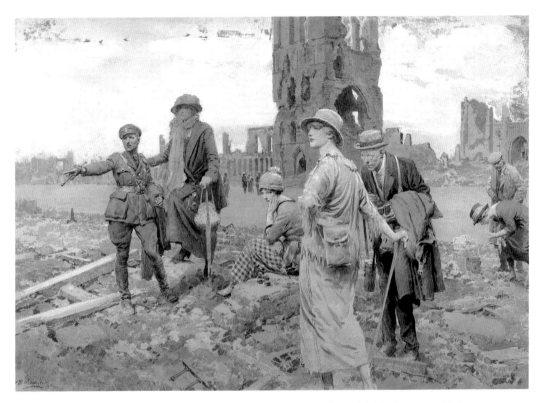

'Viewing the Battlefields.' The aftermath of war saw a wave of tourists visiting the battlefields of France and Belgium, some to find graves of loved ones and others, men who had survived, to revisit old haunts in peacetime and remember fallen comrades. These tours, or 'pilgrimages' as they were known, were run by charitable organisations such as the YMCA at a reasonable cost, but soon Thomas Cook, the tour operator, began to offer trips to the battlefields. One hundred years on, battlefield tourism remains as popular as ever. Here, an officer points out various sights around the ruined Belgian town of Ypres and no doubt ensures the safety of his visitors among the rubble and war-torn landscape. (Original monochrome artwork reproduced in *The Sphere*, 20 September 1919)

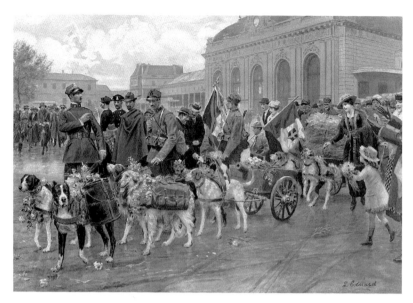

'Italian Dogs of War – Decorated for Military Services.' A variety of glamorous-looking dogs passing through the street of Milan in a picturesque procession held in honour of their contribution during the war. Armies of both the Allies and the Central Powers used dogs during the war, for hauling guns and carrying ammunition, as ambulance 'search and rescue' dogs, as guards, as sentries and, perhaps most importantly, as messengers at the front. (*The Sphere*, 20 March 1920)

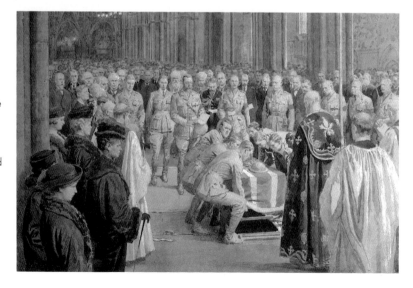

'A Scene at Westminister Abbey, 11th November 1920: "Greater Love Hath No Man Than This".' It was the suggestion of Reverend David Railton that a body should be exhumed from one of the major fields of battle on the Western Front and brought back to England where it would represent and commemorate all those who had fought and died in the war, particularly those with no known grave. (Original monochrome watercolour reproduced in *The Sphere*, 20 November 1920)

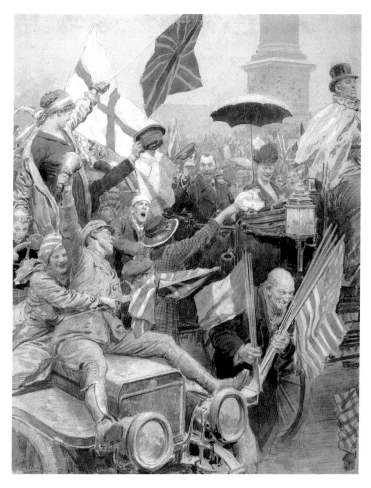

'King and People in the Streets of London, Armistice Day, November 11, 1918.' The news of the signing of the armistice on 11 November prompted spontaneous and jubilant celebrations in London. The king (in naval uniform) and queen, accompanied by Princess Mary, drove through London in an open carriage along the Mall, through Admiralty Arch, around Trafalgar Square and into the Strand, delighting the crowds along the way. Matania's impression casts the king very much as a man of the people and underlines the loyalty and admiration felt towards him by his subjects. The old man with an armful of flags in the foreground was another of Matania's regular 'character' models. (Original monochrome artwork, reproduced on the front cover of *The Sphere*, 16 November 1918)

Acknowledgements

I am grateful to David and Judith Cohen, who generously agreed to read through my text, offering suggestions, sharing their knowledge and debating the finer details of Matania's life and work with me. A number of Matania images from their collection, including 'The Strongest', are reproduced in this book. Dr John Paddock, curator at The Mercian Regiment Museum (Worcestershire), was very accommodating in supplying scans and granting permission for the use of 'Neuve Chapelle, 1915', the original of which belongs to the museum. The majority of images in this book are gleaned from *The Illustrated London News* archive, held at Mary Evans Picture Library, and combine high quality magazine reproductions from *The Sphere* with a number of original paintings still held, until recently, by the archive. I would like to acknowledge the support of ILN Ltd and their championing of Matania. Thanks also to my colleagues at Mary Evans Picture Library, Jessica Talmage and Mark Vivian, who helped out with additional caption writing when deadlines were looming. Tennants Auctioneers were very helpful in putting me in touch with members of Matania's family. Sophie Bradshaw and Rebecca Newton at The History Press exhibited exemplary patience and understanding by allowing some last minute essential changes. Finally, I am indebted to Harry Nockolds, Matania's step-grandson, who was able to provide some fascinating additional information and images at the eleventh hour. His contribution has resulted, I hope, in a book that is a worthy tribute to this most exceptional of artists.

34771314R00081

Printed in Great Britain
by Amazon